POSTCARD HISTORY SERIES

Los Gatos

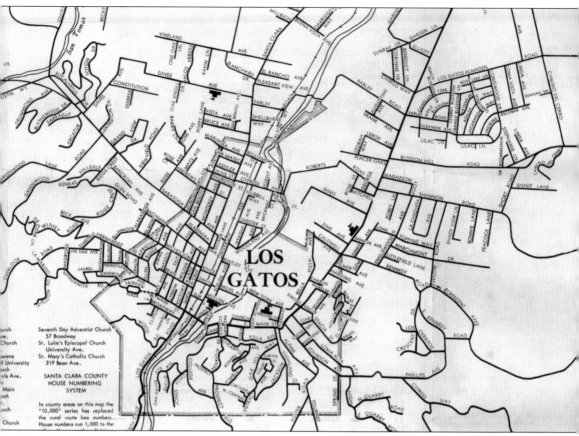

Pictured is a *c.* 1954 map of Los Gatos. (Courtesy of the Los Gatos Library and Museum History Project.)

ON THE FRONT COVER: This is the intersection of Main Street and Santa Cruz Avenue, known as "the elbow," in the heart of the downtown Los Gatos. (Courtesy of the Los Gatos Library and Museum History Project.)

ON THE BACK COVER: The Los Gatos fire station was built in 1927 at the corner of Tait Avenue and West Main Street. The building now serves as the Art Museum of Los Gatos. (Courtesy of the Los Gatos Library and Museum History Project.)

POSTCARD HISTORY SERIES

Los Gatos

Stephanie Ross Mathews and the
Los Gatos Library and Museum History Project

ARCADIA
PUBLISHING

Copyright © 2009 by Stephanie Ross Mathews and the Los Gatos Library and Museum History Project
ISBN 978-0-7385-6962-8

Published by Arcadia Publishing
Charleston SC, Chicago IL, Portsmouth NH, San Francisco CA

Printed in the United States of America

Library of Congress Control Number: 2008908330

For all general information contact Arcadia Publishing at:
Telephone 843-853-2070
Fax 843-853-0044
E-mail sales@arcadiapublishing.com
For customer service and orders:
Toll-Free 1-888-313-2665

Visit us on the Internet at www.arcadiapublishing.com

This book is dedicated to my husband, Michael, a man of infinite wisdom and patience, and to my sister Donna, who watches over me.

CONTENTS

ACKNOWLEDGMENTS

In 2003, the Los Gatos Public Library began a local history project to organize and catalog existing library materials of historic interest. A short time later, because of a shared desire to preserve and make accessible the community's heritage materials to residents, the Museums of Los Gatos joined the effort. I would like to express my sincere gratitude to Los Gatos library director Peggy Conaway for her encouragement and generosity in allowing me unlimited access to this incredible collection and permission to reproduce all of the images used in this book. I am also extremely grateful to librarian Paul Kopach for providing not only the technical expertise required but also for sharing his knowledge and enthusiasm for Los Gatos and its history.

Pat Dunning, of the Museums of Los Gatos, with her phenomenal recall of facts, has been extremely helpful and an inspiration in all things historical, and Kelly Reed, my editor at Arcadia Publishing, was always there to guide me.

Finally, I would like to thank antiques adviser and writer Steven Wayne Yvaska. As a result of a brief conversation he and I had about historic postcards, I am now an author!

INTRODUCTION

The United States issued the first pre-stamped postal cards in 1873, and only the U.S. Postal Service was allowed to print the cards for the next 25 years. On May 19, 1898, Congress passed the Private Mailing Card Act, which allowed private firms to produce the cards. The private mailing cards cost 1¢ to mail instead of the letter rate, which was 2¢. By law, writing was not permitted on the address side of any postcard until March 1, 1907. Any messages were written across the front over the photograph or artwork on the card.

Around 1900, the first "real-photo" postcards began to appear. These were postcards that had real photographs and were usually printed on film stock paper. Although most of these cards were advertising and trade cards, many were of entertainers or portraits of family members. In 1906, fashionable photograph and lithograph cards by Eastman Kodak entered the marketplace after the company made an affordable folding pocket camera. The public was now able to take black-and-white photographs and have them printed right onto postcard backs. During this time, the publication of printed postcards doubled every six months. By 1907, European card publishers began opening offices in the United States and accounted for over 75 percent of all postcards sold in the United States. Collecting picture postcards became the most popular collectible hobby the world had ever known. The official figures from the U.S. Post Office for their fiscal year ending June 30, 1908, cite 677,777,798 postcards mailed. At that time, the population of the United States was only 88,700,000.

The threat of war saw a quick decline of imported cards, and World War I brought the supply of postcards from Germany to an end. A lower quality of cards were coming from England and from publishers in the United States. The war, influenza epidemic, and the declining quality of the cards brought a swift end to the American postcard hobby. The telephone replaced the postcard as a way to keep in touch and thus ended the golden age of postcards. After World War I, the German publishing industry was never rebuilt. Most postcards were printed by U.S. publishers during this period. The higher costs of postwar publishing combined with the inexperience of the card makers significantly impacted the quality. To save on the price of ink, white borders were left around the postcards.

Soon the public lost interest in postcards and collecting, and the postcard market plummeted. Going to the movies was the new visual experience, and many postcard and greeting card publishers went out of business. The view card market, however, remained strong for many years. Real-photo card publishers were not affected by the decline. New rotary drum printers allowed publishers to print thousands of cards of one particular image, and postcard racks began to spring up at every tourist attraction.

Photogenic Los Gatos has been celebrated in every sort of media. How fortunate we are that the picture postcard was enjoying the height of its popularity at a time when the town was experiencing so many changes and that this pictorial record of everyday life has survived.

The establishment of Forbes flour mill in the mid-1800s is recognized as the birth of the town of Los Gatos. Since the very beginning, the community has attracted people who appreciate the excellent climate and natural beauty and those with an entrepreneurial spirit. It is truly the land of opportunity.

The original inhabitants were the Ohlone tribesmen, who were able to sustain themselves by hunting in the foothills for game and fishing in the creeks. They were the first to mine the cinnabar, and they developed the agricultural promise of the valley alongside the fathers of the California missions. At that point, Los Gatos was just a rest stop between Mission Santa Clara and Mission Santa Cruz. Then in 1839, a land grant encompassing approximately 6,600 acres was bestowed on Jose Maria Hernandez and Sebastian Fabian Peralta by the Mexican government. They christened their acquisition Rinconada de los Gatos.

When the lumber industry exploded in the hills above Los Gatos, the mountain communities were considered the important business centers, while the town below languished in their shadow. But as the land was stripped and the greedy loggers were forced to move over the ridge in search of more timber, Los Gatos began to thrive.

Agriculture proved even more lucrative than lumber, and the abundance of orchards and vineyards in the valley increased land values and provided employment in the fields and canneries. The railroad came to town in 1877 to transport the flour, lumber, and fruit harvest that were now the economic resources of the area. Passenger service to San Francisco was available that same year, which increased the number of tourists passing through Los Gatos on their way to the coast.

There were hotels, restaurants, shops, an opera house, and banks for the growing number of prosperous town residents and visitors to enjoy. Unfortunately, there were also catastrophic fires that destroyed entire blocks of the business district on a number of occasions. But the townspeople of Los Gatos were not deterred. After each disaster, they rebuilt the town bigger and better and celebrated holidays and special occasions with elaborate parades and pageants.

By 1915, automobile traffic was beginning to compete with the trains and trolleys traversing the town. Travelers were now passing through Los Gatos in their cars on the way to the coast, and without a train timetable to worry about, they were able to spend more time enjoying the ambiance of the charming village.

The town patriotically supported the two world wars and organized civil defense and disaster relief committees to safeguard the community. During the Great Depression, the local chapter of the Red Cross and the town board worked together to provide food, health care, and work opportunities for the needy.

The population boom following World War II spread residential development from the town center outward and gradually consumed more and more of the orchards. The quality of the local schools attracted families, and the town's proximity to the finest institutions of higher learning on the West Coast continually fed graduates into a business environment that encouraged imagination and innovation. The fertile "Valley of Hearts Delight" gave way to technology and became "Silicon Valley." Los Gatos embraced these changes but never lost its cooperative spirit and strong sense of community.

Mother Nature challenged the town in 1989 when the Loma Prieta earthquake resulted in major structural damage to many homes and businesses. Once again, the townspeople rallied and organized themselves to put the pieces of Los Gatos back together.

The affection and pride of the town's inhabitants, from the beginning to the present day, guarantee that Los Gatos will continue to be representative of all that is new and exciting while maintaining a respect for what came before. The postcard was created as a means of communication; the addition of photographs provided the opportunity to share not only words but images of a place in time. To truly appreciate the present, it is enlightening to recall the past.

One

THE CATS

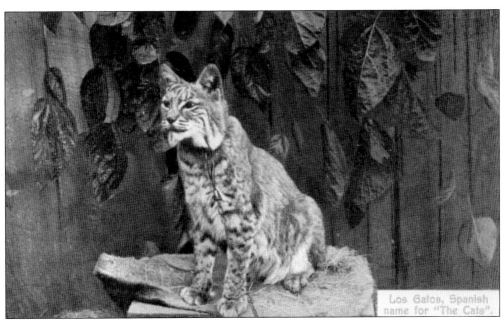

Los Gatos, Spanish name for "The Cats".

There are countless stories of how the town of Los Gatos got its name. One of the most accepted is that in 1839, when Jose Hernandez was scouting the area for farmland, he observed a large number of wildcats and mountain lions. He concluded that water must be abundant for these creatures to survive, and he christened the area Rinconada de Los Gatos—Spanish for "corner of the cats."

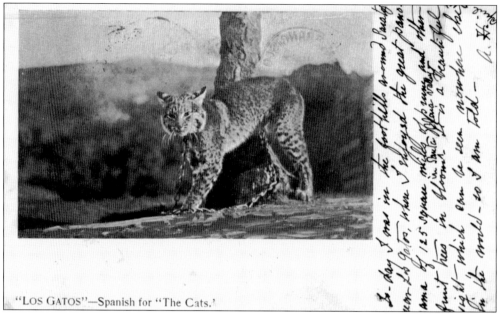

"LOS GATOS"—Spanish for "The Cats."

Wildcats of all sizes and descriptions, but mostly the stub-tailed bobcat variety, roamed the areas the Spanish explorers named for them, such as the Canyon of the Cats (Arroyo de los Gatos) and the Ridge of the Cats (La Cuesta de los Gatos).

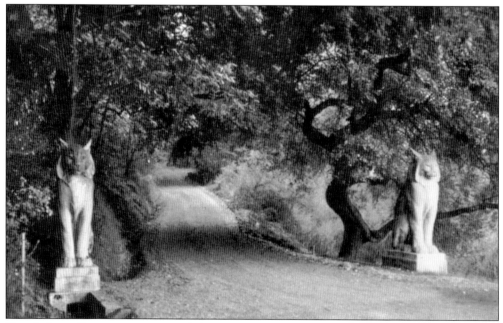

Two 8-foot-tall concrete cats guard the entrance to Poet's Canyon, the former estate of Col. Erskine Scott Wood and Sara Bard Field on the south side of town. He was a lawyer, poet, and Indian fighter and she a poet and suffragette when they took up residence here in 1919. The story of their somewhat untraditional relationship has often been retold by town historians.

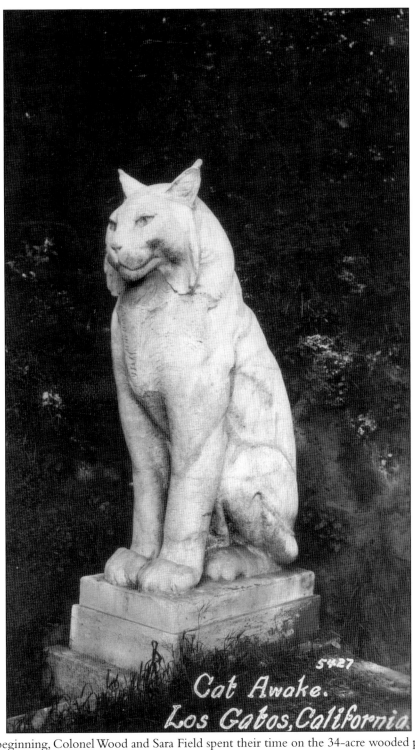

Cat Awake.
Los Gatos, California

5427

In the beginning, Colonel Wood and Sara Field spent their time on the 34-acre wooded property in the hills to the south of Los Gatos in a small shack. They cooked in a stone fireplace, read to each other, and relaxed in the solitude of the country.

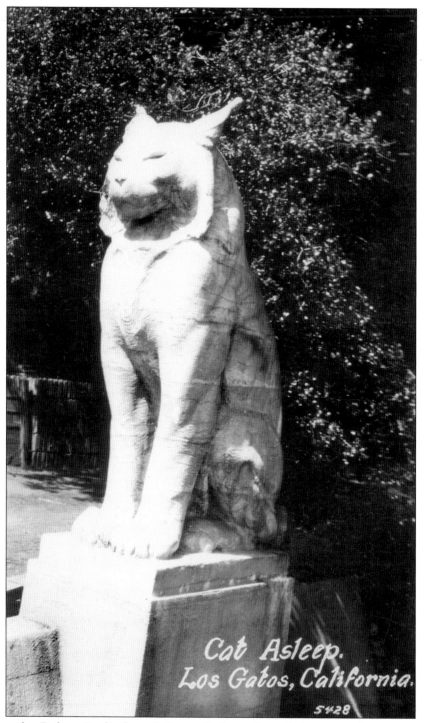

Cat Asleep.
Los Gatos, California.

5428

Sculptures by Robert Stackpole and Benny Bufano adorned the estate that was eventually completed in 1925 after Wood and Field returned from Europe. Robert Paine's cat sculptures flank the gates at the bottom of the driveway and have been vandalized several times because of their proximity to the road.

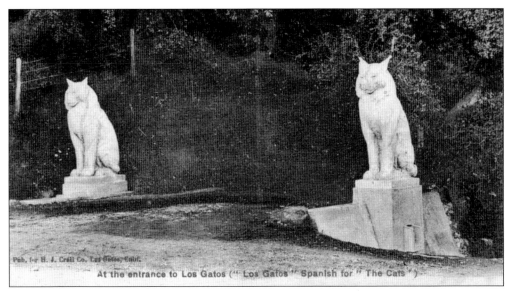

At the entrance to Los Gatos ("Los Gatos" Spanish for "The Cats")

The objective to placing the cats where they stand was to impress Californians with the idea that sculpture, in the state's mild climate, could be used to beautify highways as well as parks and museums. The intent was to interest the youth of the country in art by making it part of their common everyday experience.

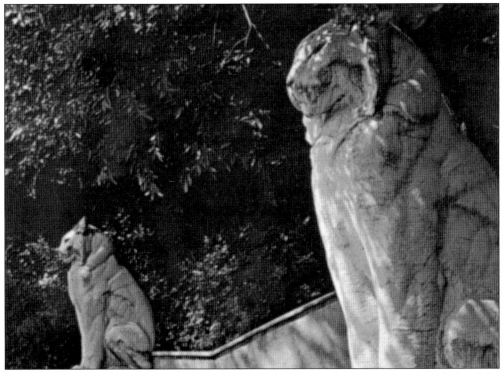

New York sculptor Robert Paine was commissioned to create the statues, not as symbols of the town of Los Gatos ("the cats") as many presume, but because of the admiration Wood and Field had for the species. Paine studied wildcats at the San Francisco Zoo, and his lifelike creations continue to attract attention as objects of interest and amusement to this day.

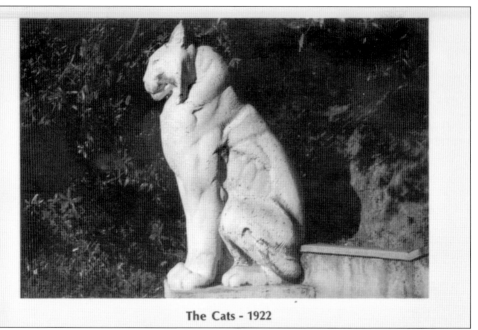

The Cats - 1922

Paine first made models of the cats using tons of clay. When these clay models were finished, he made piece molds of plaster, which were set in place on pedestals. Tinted concrete was then poured into each mold. Over the years, wind and weather have mellowed the original coloring to a natural patina.

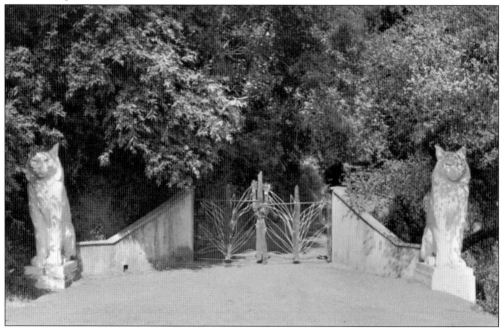

The estate was sold after Wood's death, and the new owners named the statues "Leo" and "Leona." Speculation persists, but the general consensus is that "Leona" is the one keeping watch while "Leo" naps. The initials CESW and SBF are etched into the base of each cat, visible to anyone taking the time to stop and have a close look.

Two

THE MILL, THE CREEK, AND THE CROPS

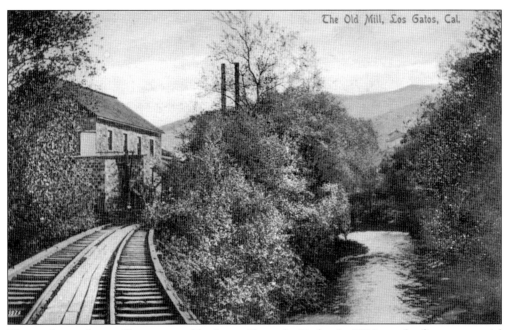

The sandstone flour mill constructed by James Alexander Forbes in 1854 was the first commercial building in what was to become the town of Los Gatos. Production of Santa Rosa Brand flour began in 1855, but James Forbes declared bankruptcy soon after and was forced to sell the mill. An annex was added in 1880, and the mill continued operations until the last flour was produced in 1887.

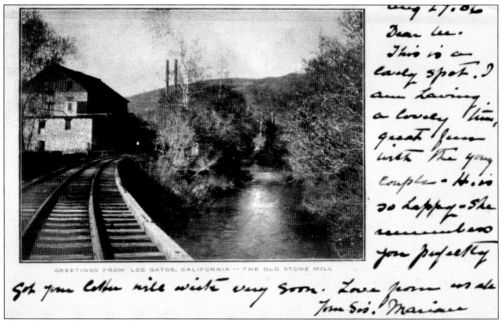

GREETINGS FROM LOS GATOS, CALIFORNIA -- THE OLD STONE MILL

The date on this postcard is August 27, 1906. By law, writing was not permitted on the address side on any postcard until March 1, 1907. Any messages were written across the front over the photographs or artwork on the card. The writer mentions that she is having a lovely time in this lovely spot.

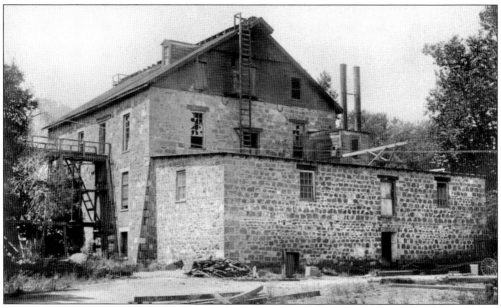

In 1887, the milling machinery was sold, and in 1916, most of Forbes Mill was torn down. In the 1920s, the land was used as a playground for the nearby grammar school. The remaining annex built in 1880 saw new life as a power plant for the Los Gatos Ice and Power Company, the Los Gatos Gas Company, and Pacific Gas and Electric until 1955.

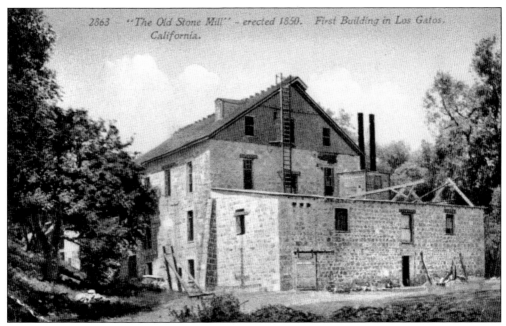

2863 "The Old Stone Mill" - erected 1850. First Building in Los Gatos, California.

This version of the same photograph identifies the structures as "The Old Stone Mill," erected in 1850. Stone for the mill was quarried from a canyon south of Los Gatos. The dark-green stones came from boulders in the creek and were said to be found nowhere else in California.

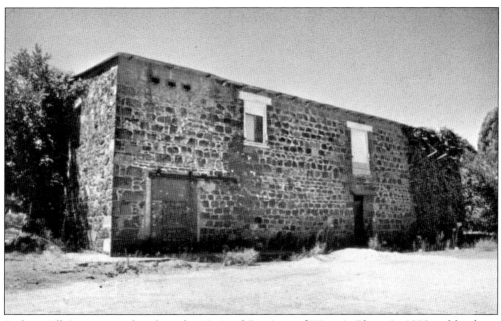

Forbes Mill Annex was placed on the National Register of Historic Places in 1978 and has been a California Historical Landmark since 1950. It was restored in 1982 and currently houses the History Museum of Los Gatos. Exhibits include rotating displays of local interest and a permanent collection including one of the original millstones.

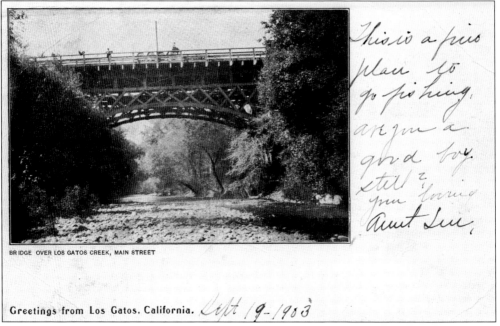

BRIDGE OVER LOS GATOS CREEK, MAIN STREET

Greetings from Los Gatos, California. *Sept 19-1903*

The proximity of water was fundamental to establishing Forbes Mill and eventually the town of Los Gatos. The wooden bridge spanning Los Gatos Creek was built in 1882 after a number of previous structures had washed away.

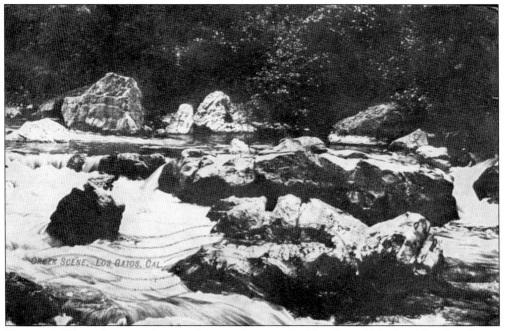

CREEK SCENE, LOS GATOS, CAL.

The creek did not fulfill the dreams of those who came looking for gold in 1849, but the climate and the soil were another of nature's riches, and the fertile valley provided opportunities for those willing to work hard. Before the waters were dammed, the fish were so plentiful it was possible to catch them with bare hands.

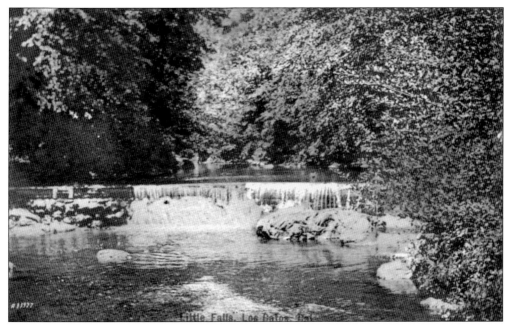

The creek overflowed so often that the ground was swampy and a haven for frogs. Winter rainfall significantly raised the level and velocity of Los Gatos Creek, changing it into a formidable threat to the town. Driftwood and debris could lodge against the bridge and cause flooding if not controlled by the workmen who were positioned as lookouts during the storms.

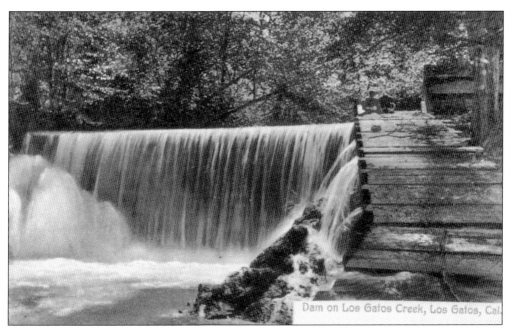

This postcard photograph is of the dam on Los Gatos Creek just south of town in the early 1900s. The waterfall formed a pool downstream where the town's boys gathered at the famous "Boogang" swimming hole. A proper swimming pool was built in Memorial Park in 1927.

A park was established south of the bridge in 1897; it was originally called Bunker Hill Park but renamed Memorial Park in 1920. A path was worn under the western arch of the bridge leading from the grammar school to the park. This idyllic scene gives no hint that during a heavy winter rainfall, Los Gatos Creek would sometimes rise as high as the arches under the bridge.

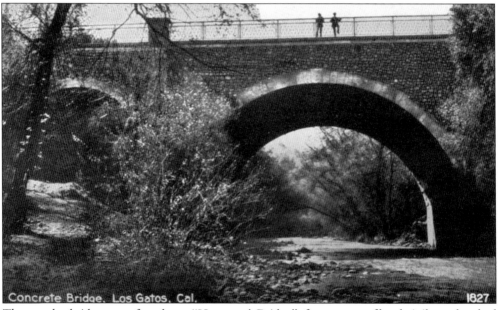

The wooden bridge was referred to as "Hangman's Bridge" after a group of local vigilantes lynched young Incarnacion Garcia on June 17, 1883. Garcia was accused of stabbing to death Rafael Miravelle, and over 200 people viewed the hanging. The old bridge was replaced by the stone and concrete Main Street Bridge in 1906.

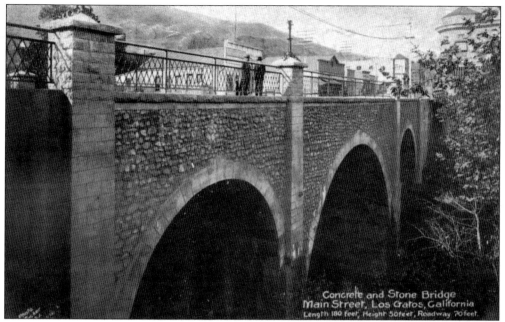

Concrete and Stone Bridge
Main Street, Los Gatos, California
Length 180 feet, Height 50 feet, Roadway 70 feet.

The citizens of Los Gatos had planned a fitting celebration for May 1, 1906, to open the largest structure of its kind in the state. The new concrete and stone bridge occupied a prominent position in the heart of the town, was 180 feet in length and 50 feet in height with a roadway of 70 feet, and cost approximately $27,000. The engineer was J. B. McMillan.

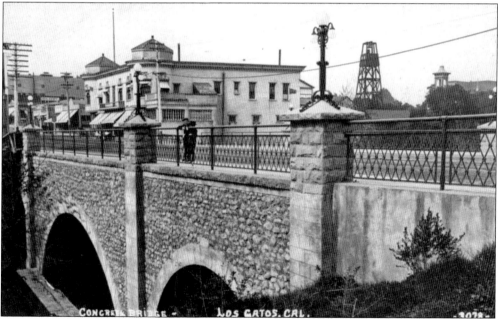

CONCRETE BRIDGE - LOS GATOS, CAL.

The press and dignitaries from neighboring counties were invited to the opening ceremony, a barbecue was planned, and Southern Pacific Railroad announced special rates for passengers traveling to Los Gatos for the dedication. Unfortunately, everything was cancelled when the San Francisco earthquake struck on April 18, 1906. The bridge was unscathed and opened without fanfare some time later but was demolished in 1954 to make way for a new highway.

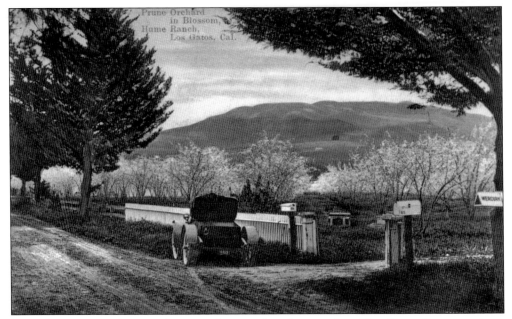

Agriculture was a major contributor to the growth and prosperity of Los Gatos. Prunes, apricots, apples, walnuts, and grapes all thrived, and the orchards provided employment for many area residents. This 1907 postcard depicts the prune orchard in bloom at the Hume Ranch, which now lies outside the redrawn boundaries of Los Gatos.

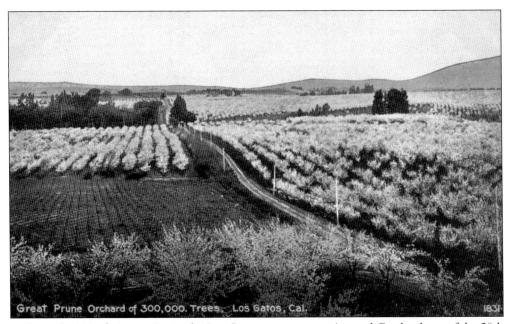

In the mid–1800s, fruit growing in the Los Gatos area was experimental. By the dawn of the 20th century, there were approximately 4.5 million prune trees in the Santa Clara Valley producing 135 million pounds of prunes. "Make the Prune Known Everywhere" was the slogan of Prune Week in October 1915.

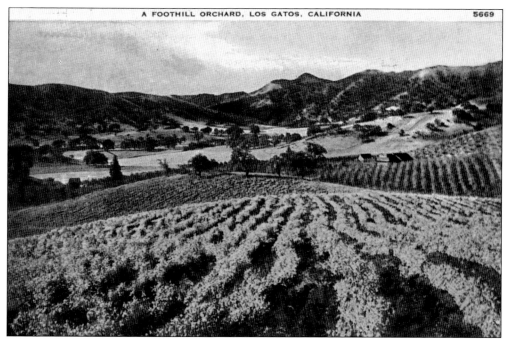

The soil and climate in Los Gatos were ideal for raising fruit of all kinds, and the proliferation of artesian wells ensured a plentiful supply of water all over the valley. The mission fathers supplied many of the young trees for the area orchards and shared their considerable knowledge on how to care for them.

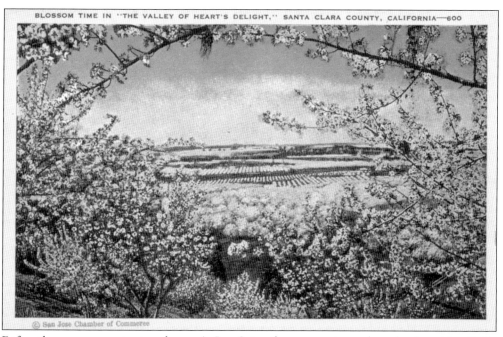

BLOSSOM TIME IN "THE VALLEY OF HEART'S DELIGHT," SANTA CLARA COUNTY, CALIFORNIA—600

© San Jose Chamber of Commerce

Before there were any streets or houses in Los Gatos, there were vineyards, orchards, and hay fields. An area west of Santa Cruz Avenue was known as the Almond Grove, and in the spring, this district was a sea of pink and white blossoms.

23

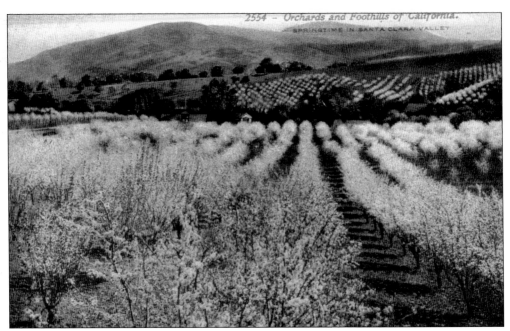

As word of the bounty spread, land values began to rise and farmland that had been selling for $15 to $20 an acre was now going for $40 to $60 an acre. Land that was considered worthless for growing grain was now treasured for the fruit trees and vines it was perfectly adapted for.

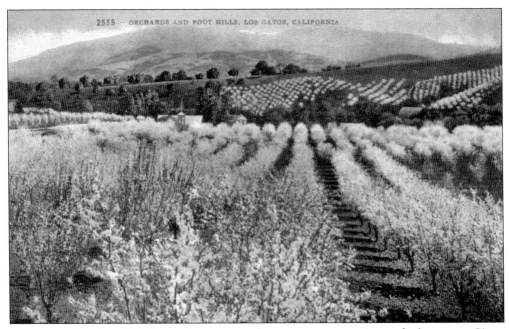

Citrus were also planted in the area but were used more as ornamentation or for home use. Citrus never became very important as an agricultural industry in Los Gatos because the other fruits were more profitable. The most popular and profitable fruit grown in the valley was the prune.

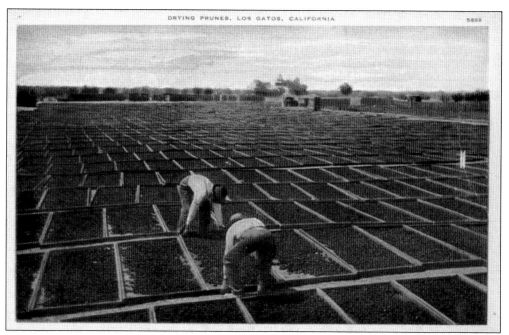

Originally prunes were harvested after they had ripened and dropped to the ground. They were then dipped in lye and put on flat trays to dry. Los Gatos was filled with wide open spaces transformed into drying yards as illustrated in this 1909 image. More than 7 million pounds of sun-cured fruit was produced annually.

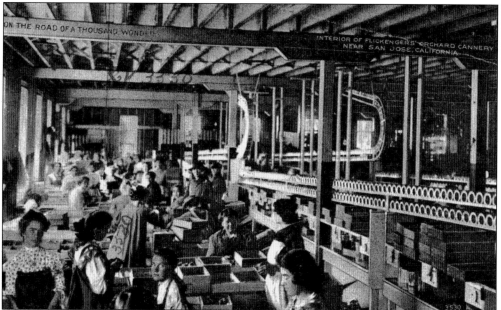

Besides drying, the easiest way to get the fruit crop to market was to process it and put it into cans. The Los Gatos Fruit Company packed an average of 50,000 cases of fruit annually and during the peak season employed between 250 and 300 people, mostly women and persons under 21. Due to competition from the larger canneries, the Los Gatos Canning Company was abandoned in 1955.

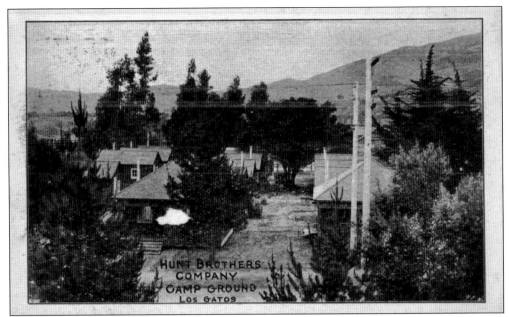

In 1906, Hunt Brothers Company of Hayward purchased the Los Gatos Cannery from George Hooke. The Hunt Brothers Company Campground provided housing for the laborers and was located across the road from the cannery on the former site of the Los Gatos Cemetery. During the peak season, Hunt Brothers Company would hire as many as 800 workers.

Vineyards flourished in the rich soil of Los Gatos, and selling grapes to the wineries in the area was very profitable. For a short time from 1893 until 1896, condensed table syrup made from grapes was successfully produced and marketed by California Sanitas Grape Food Company as a valuable medicine for just about any malady. When demand for the elixir declined, the company went out of business.

Three

THE LANDMARKS

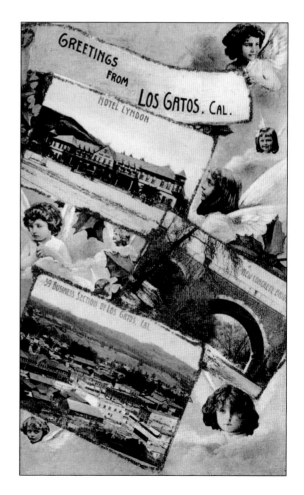

A promotional holiday greeting card issued by the chamber of commerce features angelic figures and holly sprigs surrounding a few of the town's notable historic landmarks. The Hotel Lyndon is pictured along with the new concrete bridge, built in 1906, and a bird's-eye view of the business section.

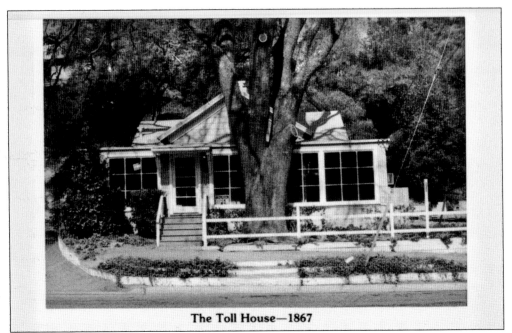

The Toll House—1867

The Santa Cruz Gap and Turnpike Company charged tolls to pay for improvement and maintenance of their roads from Los Gatos into the Santa Cruz Mountains. James Kennedy built the toll house in 1867 as a residence and source of income. Fees ranged from 50¢ for a single-horse team up to $1 for a six-horse team.

In 1877, the charter expired, and teamsters dragged the toll gates across the wooden bridge and dumped them into the creek. In 1878, the first team through newly rebuilt gates dragged them into the creek for the final time. Some of the original components of James Kennedy's redwood shack remain in the building that now serves as office space on the corner of Santa Cruz Avenue and Wood Road.

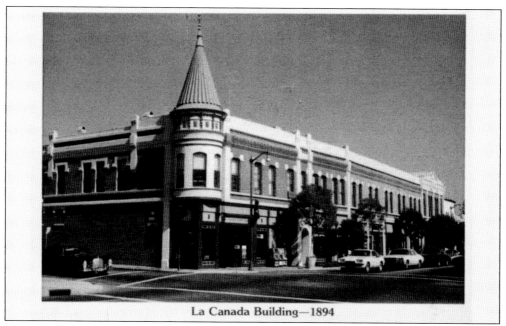

La Canada Building—1894

The cupola at the intersection of Santa Cruz Avenue and Main Street was built atop the single-story Hofstra building in 1875. The valuable frontage was expanded to two stories, following the lead of neighboring businesses around 1917. It was renamed La Canada, Spanish for "the valley" and a reference to the Valley of Heart's Delight. Descendants of the town's earliest families sponsored repairs when it was damaged during the 1989 earthquake.

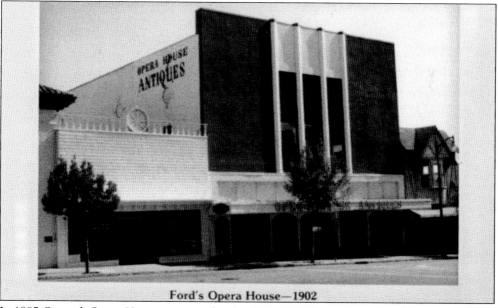

Ford's Opera House—1902

In 1885, Seanor's Opera House was completed on East Main Street near Church Street, but it was destroyed by fire in 1890. Its successor, the Johnson Opera House, opened in 1893 but soon fell victim to the same fate when it burned to the ground in 1894. Ten years later, in 1904, the Ford Opera House opened. An updated version remains with retail shops on the lower level and a two-story banqueting facility above.

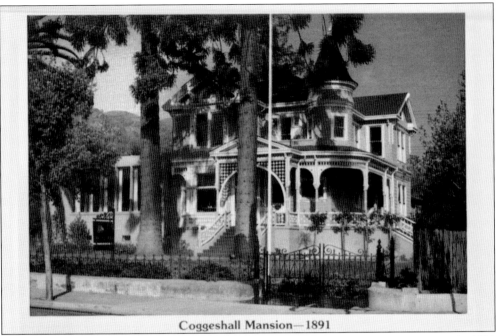

Coggeshall Mansion—1891

Mary Coggeshall, a native of Australia and a widow, built this house on Santa Cruz Avenue in 1891 for herself and her children. Elvert Ernest Place, undertaker and furniture salesman, converted the house into a mortuary, which operated from 1917 until 1976. In its third incarnation, this classic Queen Anne with turret and wraparound porch has been a popular dining spot for over 30 years.

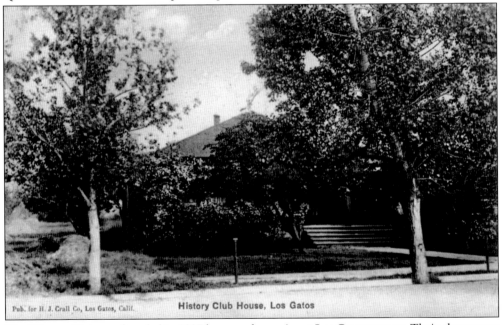

Pub. for H. J. Crall Co, Los Gatos, Calif. **History Club House, Los Gatos**

The History Club was founded in 1897 by several prominent Los Gatos women. Their charter was to explore the world; one year, each member wrote a letter home from an imaginary cruise around the world. In 1907, the women purchased property for a clubhouse on San Jose Road. The current structure on the site was built in 1958.

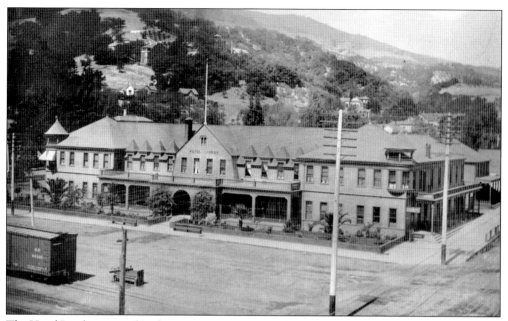

The Hotel Lyndon opened its doors on June 1, 1899, on the site previously occupied by the Los Gatos Hotel, which was destroyed by fire on May 26, 1898. The new hotel faced onto Santa Cruz Avenue opposite the train depot. The extravagant appointments included velvet carpets and fine linens. There was a gentlemen's sitting room and a ladies' parlor all tastefully furnished and decorated.

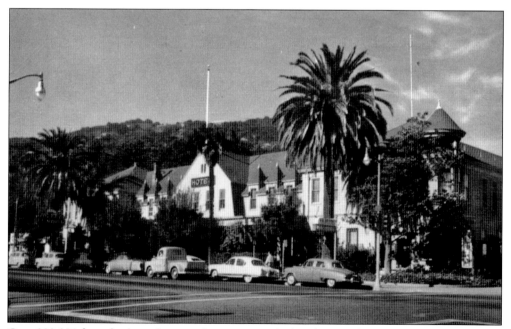

Over 300,000 feet of redwood was used to construct the hotel, most of it supplied by John Lyndon's brother. A road extended around the perimeter of the building, and the two palm trees that Lyndon planted in 1901 still remain to mark the spot where the hotel stood for nearly 64 years.

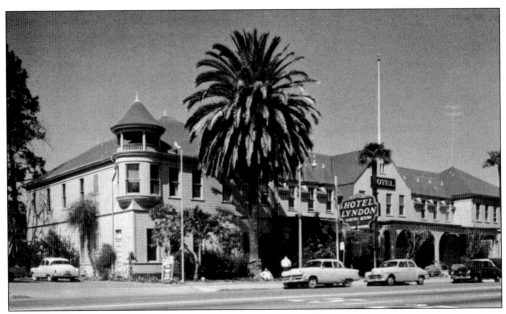

There were 60 bedrooms in the Hotel Lyndon, and many famous people were guests during its heyday. Local resident John Steinbeck met John Ford and Charlie Chaplin for drinks in the bar when they passed through town.

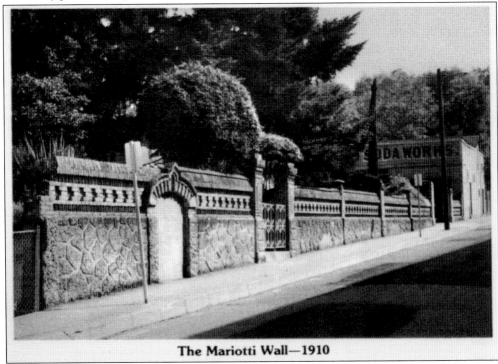

The Mariotti Wall—1910

The Mariotti Wall is all that remains of the first Los Gatos Hotel and Saloon. In 1904, the hotel was purchased by Luigi Mariotti, and in 1910, he commissioned an Italian stonemason to build a wall that would enclose the property. The stonemason was called home to Italy after a death in the family and never returned, leaving the wall only partially completed.

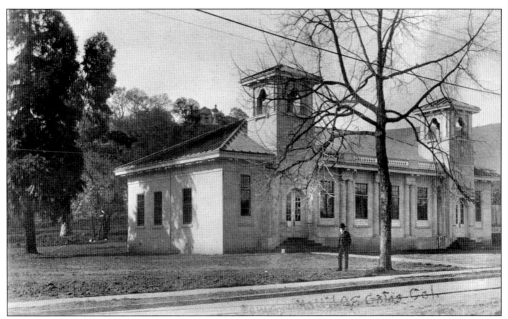

In January 1913, plans for a town hall in Los Gatos were submitted by architects E. J. Symes of Oakland, H. C. Smith of Los Gatos, and William H. Crim of San Francisco. The site they selected was the corner of East Main Street and Wilcox Avenue, and they informally agreed with the town board that if the site was offered it would be accepted.

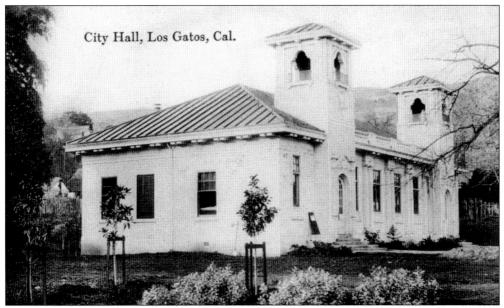

In May 1913, the architects presented revised plans. The earlier designs had been wood and plaster construction, and the latter was updated to reinforced concrete. With the stipulation that any plan should not exceed $9,500 including architects' fees, the new plans were adopted. In June 1913, the construction contract was awarded to T. F. Spidel of San Francisco, who had bid $8,958 for the job.

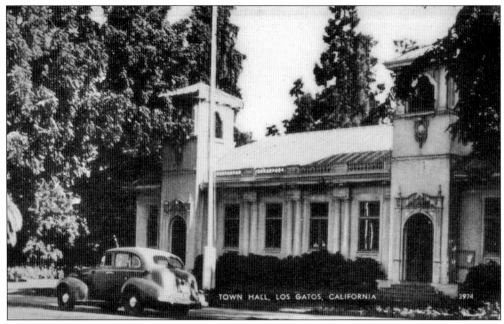

The town hall was completed in November 1913 and was deemed a credit to the town, giving class to the section in which it was located. It was constructed of reinforced concrete with a white cement finish and had amenities such as a burglar and fireproof safe, a steel filing case, quarter grain oak furniture, and the very latest in electric lighting.

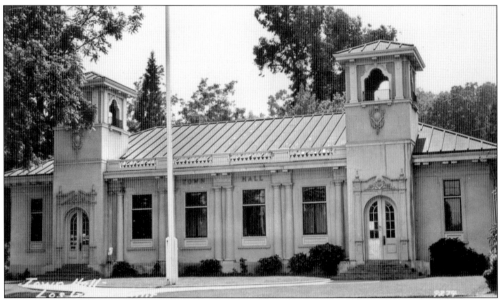

The town hall was dedicated on December 12, 1913, and served Los Gatos for 50 years. By 1962, the structure was showing its age and was the subject of much controversy. Residents were divided on whether to refurbish it and maintain it as a museum or to tear it down. In the end, the old building was demolished, taking more hits from the wrecking ball than anyone could have imagined.

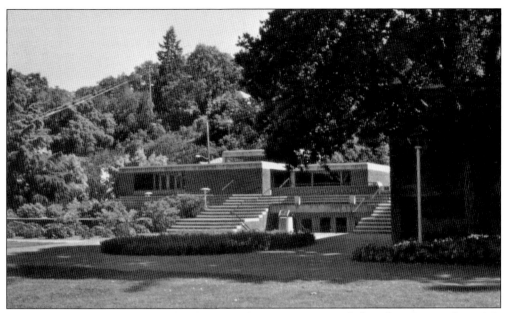

In 1962, the town of Los Gatos decided to replace its aging town hall with a new, modern civic center complex, and a design competition was implemented. The budget was $500,000, and 81 plans were submitted for consideration. Architects Charles Stickney of Berkeley and William Hull of Hayward won the contract and completed construction in 1966.

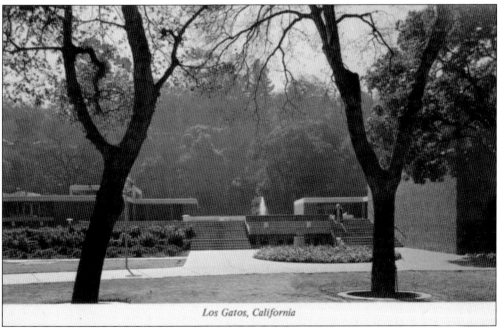

Los Gatos, California

The design selected for the new civic center saved practically all the trees on the site and kept the Main Street side landscaped and park-like in appearance. It is the venue for the annual summer music series and many other community activities. Incorporated into the set of buildings are the library; town offices, including the council chambers; and the police department.

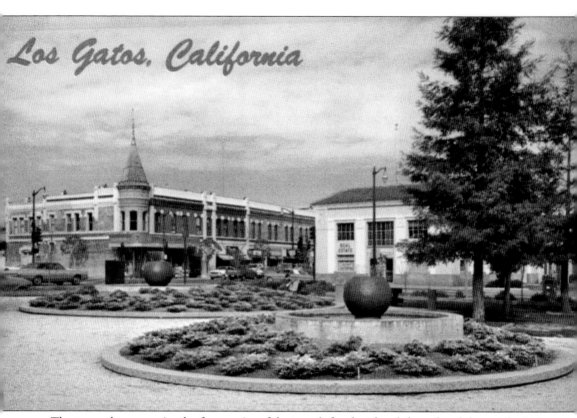

Los Gatos, California

The town plaza occupies the former site of the town's first hotel and the railroad depot. The U.S. Post Office faces the south end of the park, which remains the hub of Los Gatos. The Christmas tree planted by the History Club in 1923 continues to delight the community when thousands of lights are illuminated each December. In the summer, open-air jazz concerts attract huge crowds.

Four

RELIGION, EDUCATION, AND HEALTH

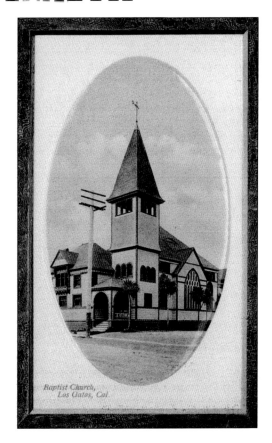

Baptist Church,
Los Gatos, Cal.

The First Baptist Church in Los Gatos was
organized in 1883 by 16 people who had
been members of the First Baptist Church
in San Jose. Their first church building was
erected on West Main Street and dedicated
in May 1889. It had a seating capacity of 400
and the second pipe organ in Los Gatos.

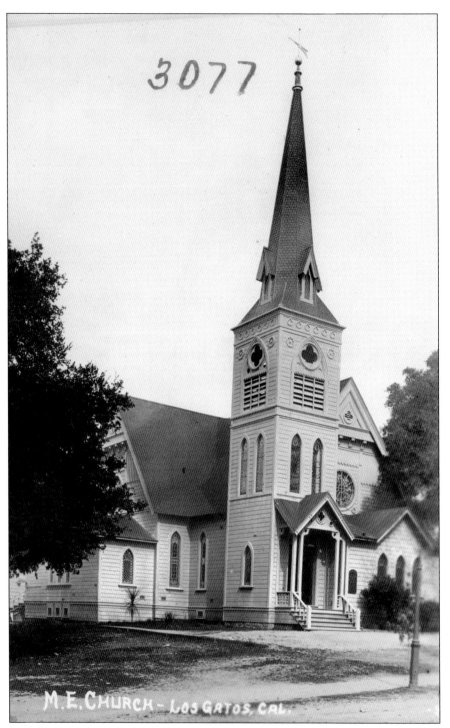

In 1867, land was purchased for a $1 gold coin from the owner of Forbes Mill, and this Gothic structure, dedicated in December 1889, was built on the site of the original meeting room. In 1923, the group purchased the property across the street from the front of the church building for $10,500.

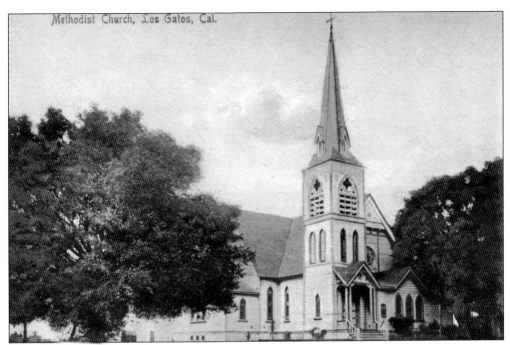

The first religious congregation in Los Gatos was the Methodist Episcopal, which was established in 1866. The Methodist church was the only church in Los Gatos for 15 years, and the first clergyman was a physician—not an ordained minister. In 1879, there were 32 members in the congregation.

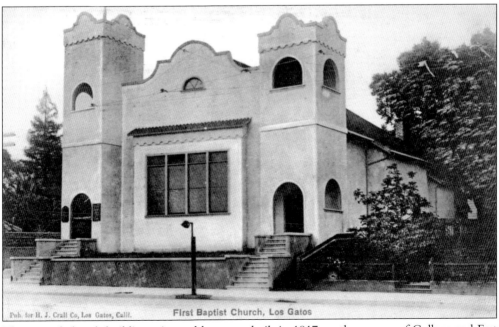

First Baptist Church, Los Gatos

The second church building, pictured here, was built in 1917 on the corner of College and East Main Streets. It was torn down in 1958 to make room for the Penthouse Apartments building. A new church was built on Farley Road and dedicated in March 1963.

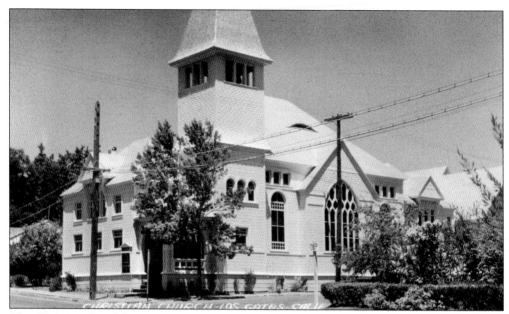

The Christian church located on Lyndon Avenue and West Main Street was built by the Baptists in 1889. When the Baptists moved to their new location on Main Street and Wilcox Avenue in 1917, the impressive building was sold to the Christian church. The congregation thrived and grew rapidly and in 1956 realized it would have to move away from the downtown area.

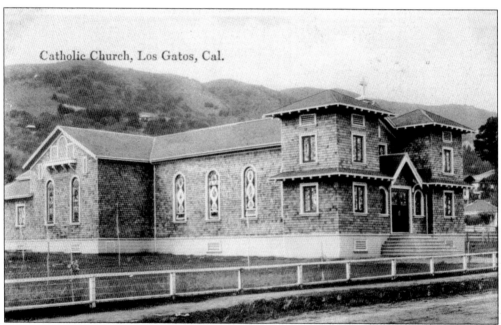

Catholic Church, Los Gatos, Cal.

Although mass was celebrated in Los Gatos before 1880, there was no Catholic church building until 1881. At that time, it was attended by Jesuits from the Sacred Heart Novitiate and remained a mission church until 1912. In 1913, St. Mary's was moved two blocks and became part of a larger church complex. A new church was built in 1914, and the parish grounds were beautified with trees, flowers, and shrubs in the 1920s.

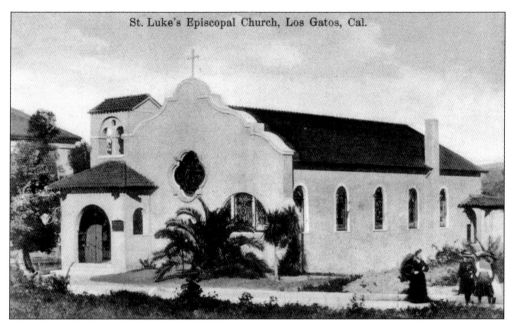

St. Luke's Episcopal Church, Los Gatos, Cal.

The original Episcopal church in town was a wooden structure located on University Avenue. It was destroyed by a major fire in 1901. The majority of funds to build a new church were raised by the parish of St. Luke's in Germantown, Pennsylvania, and in appreciation, the 1902 mission-style replacement was named in their honor.

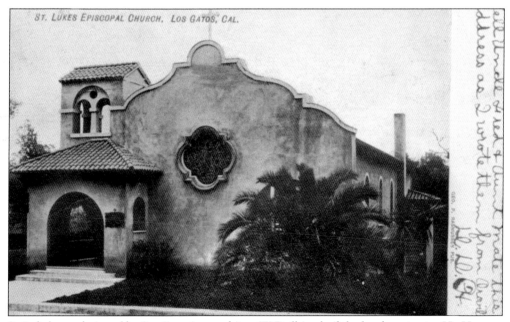

St. Luke's was designed by San Francisco architect W. Dolhim, built by local contractor Hy Hooper, and painted by local resident Jack Sullivan. The church was situated next to the Carnegie Library from 1903 until 1953. When the library was condemned and subsequently torn down in 1954, St. Luke's was able to expand its facilities.

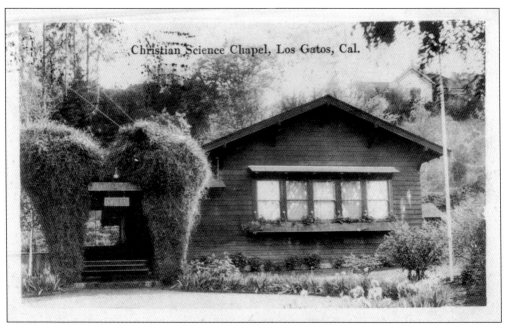

In March 1909, the Christian Science Chapel and reading room were built on Broadway. It was also used for Sunday school. It had a seating capacity of 130 and every modern convenience, including Tungsten electric lights. The building cost $3,500, but by 1929, the growing congregation needed a larger space.

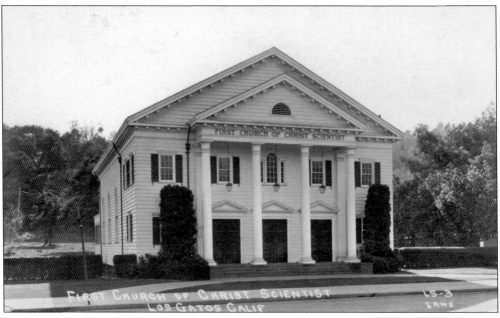

Designed by architect William Crim Jr., who also designed the original Los Gatos Town Hall, the First Church of Christ, Scientist is located on East Main Street. This impressive structure with its Corinthian influences was completed just after the stock market crash of 1929, and the first service was held in February 1930.

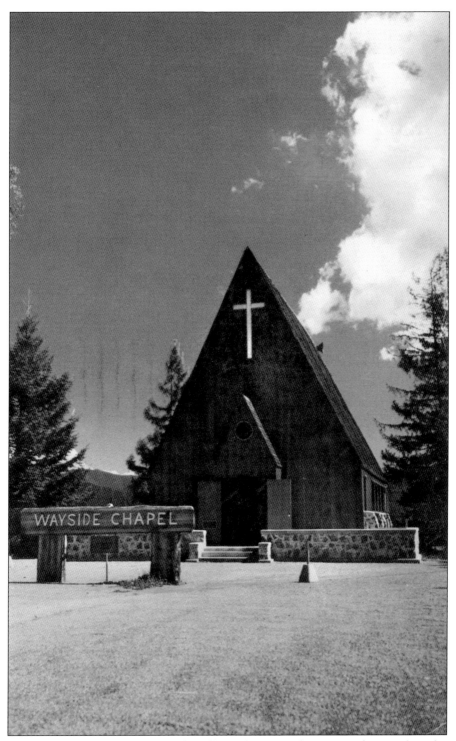

The Wayside Chapel was once a quiet place for meditation and prayer. Unfortunately, its location alongside the busy Santa Cruz Highway in the mountains above Los Gatos eventually affected its popularity, and the property was put up for sale.

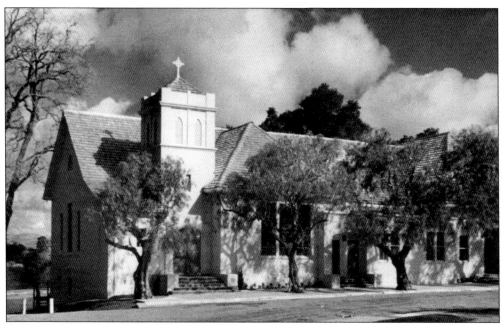

First Presbyterian Church was established in 1881, and the building on Church Street was dedicated in May 1885. It was remodeled in 1894 and again in 1938, when pews replaced 40-year-old opera chairs. The church bell also served as the town fire bell when necessary, but by 1953, there was no more room to expand, and the church relocated to another part of Los Gatos.

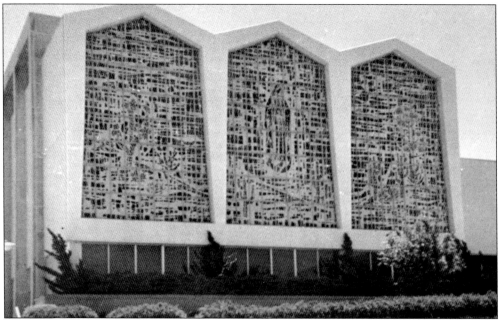

One of the most beautiful settings for an educational institution was that of Guadalupe College above Los Gatos on Foster Road. Pictured here is the college chapel, built at a cost exceeding $3 million by the Sisters of Charity of the Blessed Virgin Mary in 1963 and dedicated in 1964. The first and only class, composed of 13 women, completed its training in 1968.

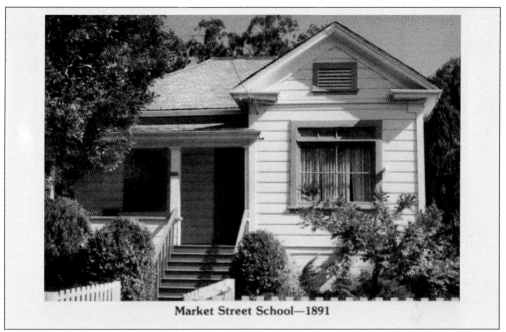

Market Street School—1891

Built in 1891, this residence served double duty as a schoolhouse in 1894 when one room was used as a primary school for first and second graders. One of the teachers, Elvira V Johnson, was believed to have been the daughter of the original owner of the house. The Market Street School became a residence again in 1917.

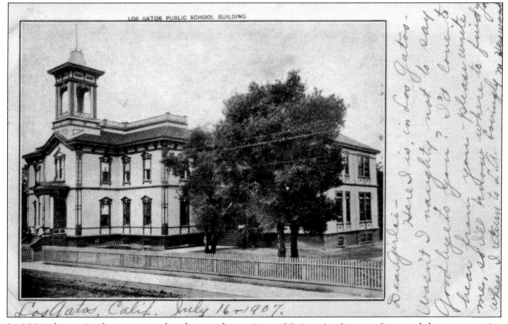

In 1881, the main elementary school moved to a site on University Avenue. It served the community well for a few of years but by 1884 was already overcrowded. After discussions about whether there should be two schools, one on the east side and one on the west, a new wing was approved and completed in 1885.

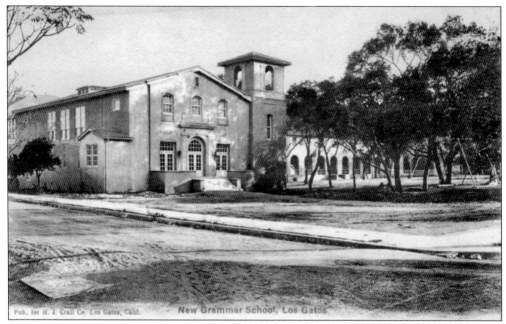

The high school wing was built next to the grammar school in 1893. High schools were not favored in many parts of the country prior to 1890, but neighboring colleges such as Stanford University and Santa Clara University were willing to accept local students by examination. The high school opened in 1894 and graduated its first class in 1897.

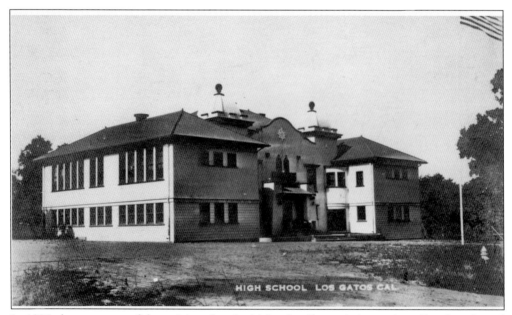

In 1907, the town was of the opinion that the high school's proximity to the railroad tracks and business section of town was detrimental to the progression of the students. The trustees were instructed to purchase a house and lot on Church Street a block and a half from Main Street and far away from the railroad.

46

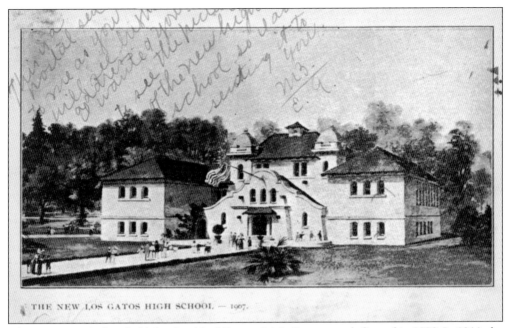

THE NEW LOS GATOS HIGH SCHOOL. — 1907.

The mission revival–style high school building on Main Street was dedicated in 1908. In 1911, the high school board proposed purchasing additional land for expansion. Between 1923 and 1925, major renovations swallowed the original building, leaving only a small portion that was used as a wood shop until 1954, when it too was demolished.

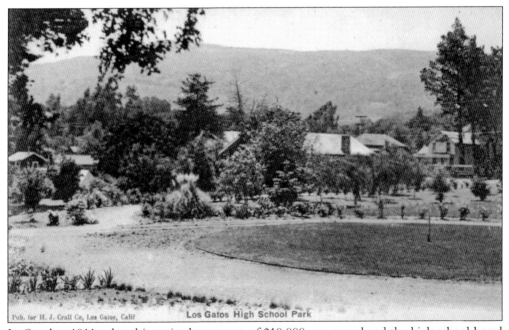

Pub. for H. J. Crall Co, Los Gatos, Calif Los Gatos High School Park

In October 1911, a bond issue in the amount of $10,000 was passed and the high school board purchased the land on East Main Street for $7,500. A shed for horses and cars was built on the land in 1913 and remained in use until 1968, when it was torn down to make room for a new science building.

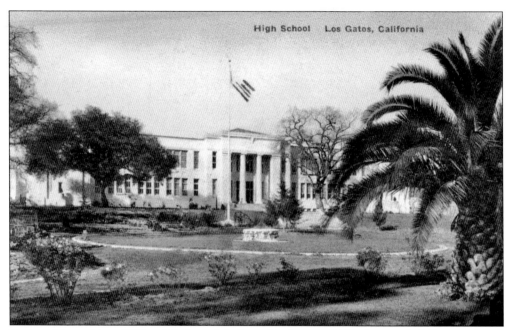

Designed by architect William Weeks and dedicated in January 1925, the new building continued to grow. During construction of music and classroom wings in 1935, the flame from a worker's lantern ignited accumulated gas in the basement. The worker was blown out of the building, and considerable damage was done to the uncompleted structure, but all 600 students attending an assembly nearby escaped injury.

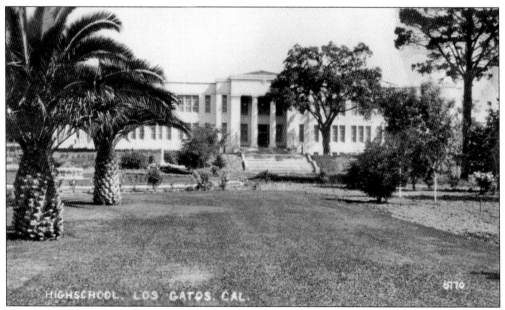

The Los Gatos Union High School, set amid palm trees, oak trees, and beautiful expansive lawns, was extended again in 1954 with the addition of an industrial arts building, a home economics building, a new gymnasium, and a swimming pool. In 1963, a library and science wing were added.

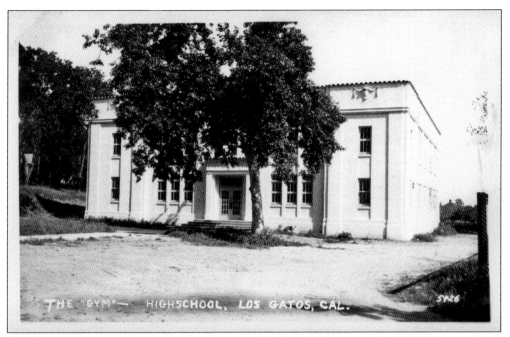

The impressive gymnasium pictured here was added in 1954 as part of a $500,000 bond issue approved for improvements to the high school. Coach Douglas Helm joined the staff of Los Gatos High School in 1923 and became vice principal in 1938. He remained a popular coach and administrator until his death in 1953, when the school's athletic field was named in his honor.

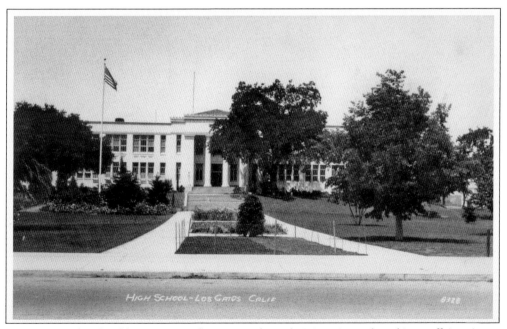

Los Gatos High School has maintained an outstanding administrative and teaching staff since it was established. The people of the town are extremely proud of the continued standard of excellence. The park-like lawn area in front of the school is the perfect venue for the annual graduation ceremony, town Fourth of July celebrations, and many other civic and social events.

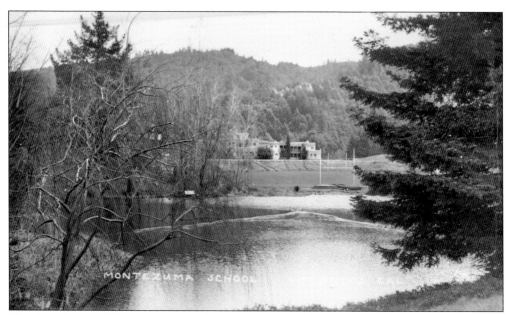

The first classes at Montezuma School for Boys were held in January 1911. The private school was established by Ernest Andrew Rogers to fulfill his dream of developing young men of good character in a wholesome atmosphere on ranch property purchased by his family in the mountains above Los Gatos.

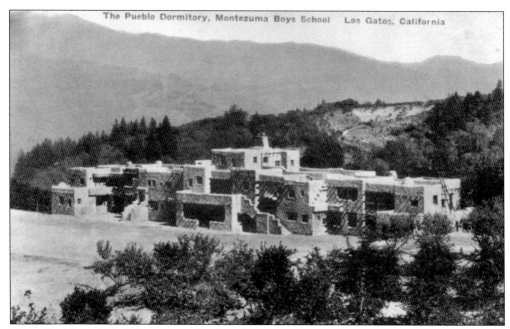

Three Pueblo-style buildings were added to the original ranch house and outbuildings to create classrooms and dormitory space for the boys. In 1953, a fire destroyed the building that housed the school kitchen and dining room, the assembly hall, and the bookstore. Professor Rogers was in failing health, and the school was closed in 1955 and sold to the Sisters of the Presentation.

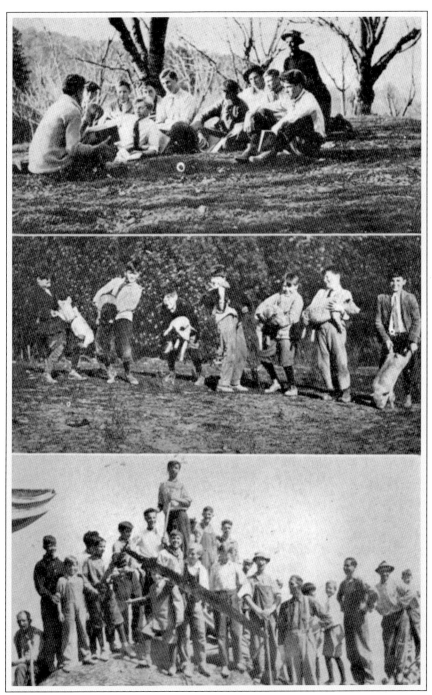

At the Montezuma School for Boys, students were introduced to a new concept in education. Academic classes were held in the morning, and the afternoons were spent on extracurricular activities such as swimming, hiking, horseback riding, and athletics. Junior Statesmen, a national movement to educate students in good citizenship, was started by Professor Rogers. Local chapters were established all over the United States, and seminars were held at Montezuma in the summer.

From 1958 until 1971, the atmosphere of education, love of nature, and respect for mankind that had characterized the Montezuma years would continue in a new and different direction in the heart of the Los Gatos hills. At Presentation College, an affiliate of the University of San Francisco, young women were trained and prepared spiritually, intellectually, and professionally for their future work as religious teachers.

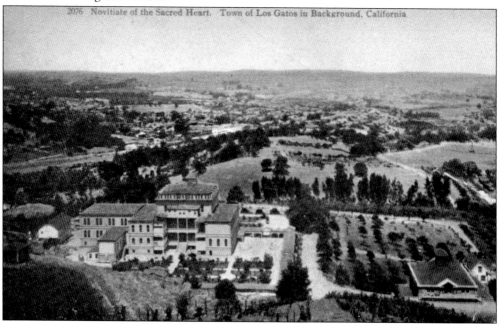

After being disappointed by a number of prospective sites on which to build their new seminary college, the Jesuits from Mission Santa Clara were invited to view a property that stood just south of Los Gatos at an altitude of 700 feet. The 39 acres included a vineyard and orchard with a variety of fruit trees. The location and solitude met their needs, and the land was purchased for $15,000 in March 1886.

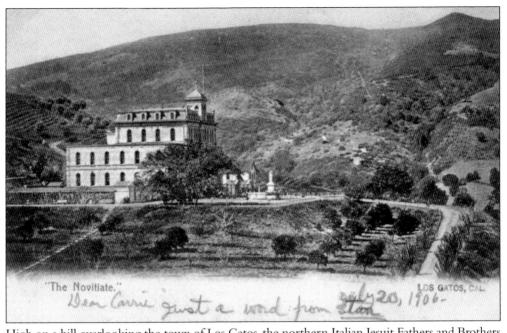

"The Novitiate."

Dear Carrie just a word from Stan July 20, 1906 -

LOS GATOS, CAL

High on a hill overlooking the town of Los Gatos, the northern Italian Jesuit Fathers and Brothers from the college at Mission Santa Clara, now Santa Clara University, built the Novitiate of the Sacred Heart. The term novitiate simply translates to "the house of novices," the name used for seminary students.

GROTTO - NOVITIATE OF LOS GATOS

The novices rose at 5:00 a.m. and spent an hour in solitary meditation. All meals were eaten in silence save for the noon meal, when the novices were permitted to listen to a book being read aloud. There was a one-hour recreation period midday when conversation was allowed and another 45-minute period following supper. Evening prayer at 9:00 p.m. ended each day.

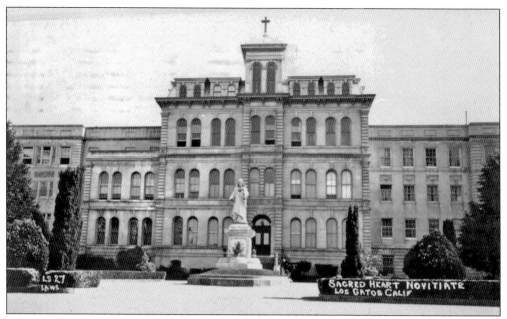

Under the guidance of Fr. Dominic Giacobbi, the property holdings of the Novitiate had reached 247 acres by 1893. The second central portion of the building, containing the chapel, was added in 1914. The number of novices was increasing rapidly, and in 1926, a large new Novitiate wing and another Juniorate wing were added, making the complex one of the most beautiful in California.

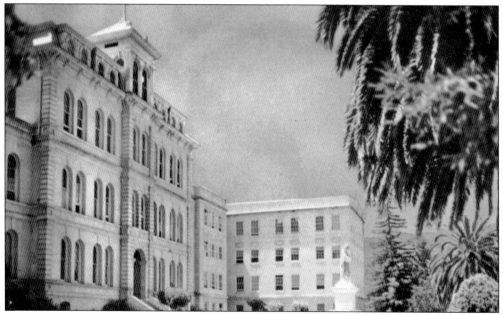

After four years of training at the Novitiate, the young men went on to Michigan, where they would study philosophy for three years. This would be the equivalent of the last two years of college and one year of postgraduate work. After that, they were required to teach for three years in Catholic high schools.

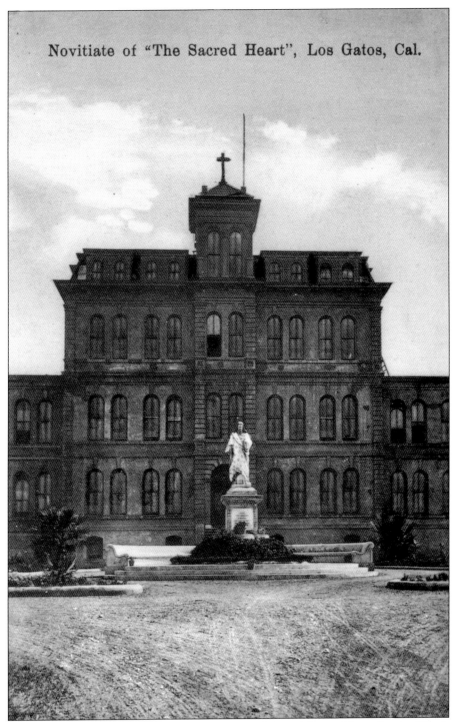

Novitiate of "The Sacred Heart", Los Gatos, Cal.

The central portion of the Novitiate building was designed by architect Bryan Clinch, and construction was completed in April 1988. In June, the novices moved in and the first mass was celebrated. Father Giovanni Pinasco was the Novitiate's first Superior and Master of Novices, soon succeeded by Fr. Paul Mans, who served until his death two years later.

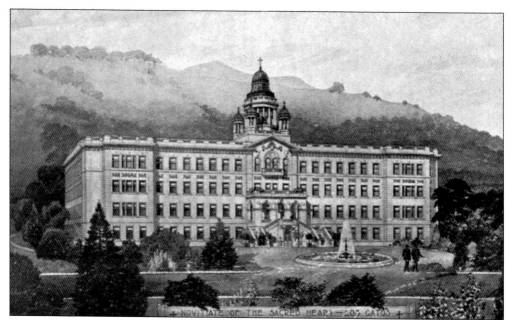

This postcard was sent by one of the Sacred Heart novices in 1914 to his family. The message he wrote was, "I am happy in my vocation and I hope to remain in it all my life." Despite the extreme demands of his training, the writer had "not yet experienced a feeling of isolation or homesickness."

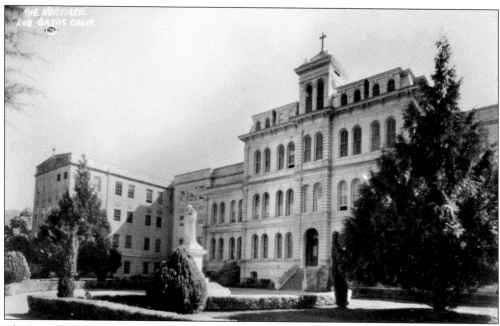

The Sacred Heart Novitiate became the head office of the California Province of the Jesuits, which included California, Nevada, Arizona, and Utah, plus five high schools and three universities—San Francisco, Loyola, and Santa Clara. But in the 1960s, the seminary population began to decline, and in 1968, a decision was made to shut down the seminary college and move the students to Santa Barbara.

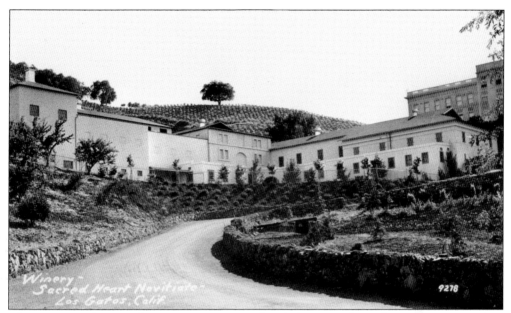

The winery at the Sacred Heart Novitiate was founded in 1888 by Father Pinasco to produce high-quality sacramental wines. Harvesting the grapes was part of the training for the young Jesuit novices. A fine example of 19th-century construction, the winery was based on gravity flow. The winery closed in January 5, 1986, after 97 years of operation and reopened as M. Marion and Company the very next day.

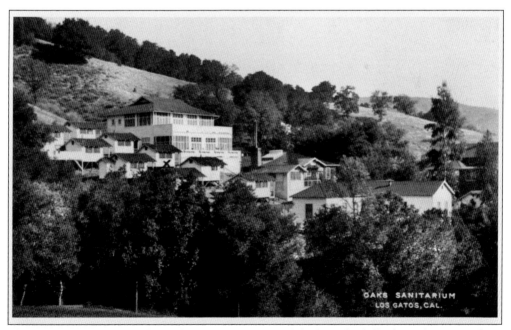

The Oaks Sanitarium was located on Montevina Road, high in the hills above the town of Los Gatos. It was the best known of many such facilities because the climate was believed to be very healthy. Doctors across the county sent patients who were suffering from tuberculosis and severe asthma to the Oaks in the hope of prolonging their lives.

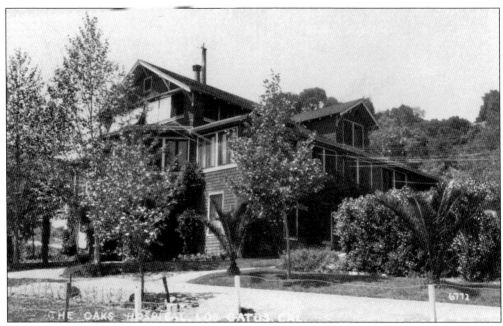

An influx of people suffering from rheumatism, consumption, and asthma descended on Los Gatos hoping to be cured. On July 10, 1919, the Oaks Sanitarium was threatened by fire, but the wind carried the blaze to one side, and the fire passed on by.

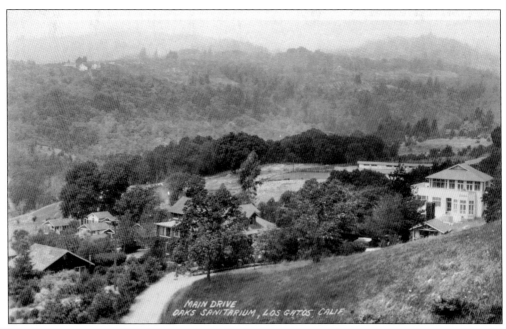

In a 1910 newspaper advertisement, the sanitarium was characterized as a resort for the tubercular and for those afflicted with diseases of the throat and lungs only. For a moderate charge, patients were guaranteed outdoor rest and sleep in absolute privacy under the cottage tent plan. Despite such care, many patients died, but some were relieved of their discomfort and lived beyond their expectations.

Five

DOWNTOWN

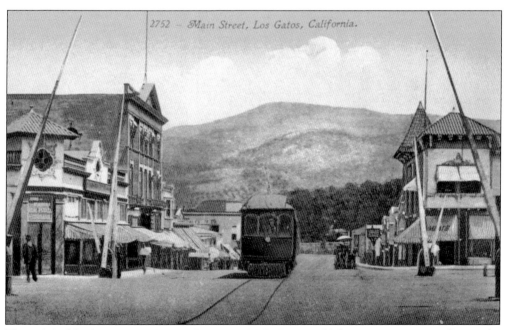

The original business center in Los Gatos was Main Street, which ran east to west ending at the southeast corner location of the train depot. This early rendering depicts the interurban trolley traveling east down Main Street toward the creek and Forbes Mill. The railroad crossing barriers for both the interurban and the train are shown in the foreground.

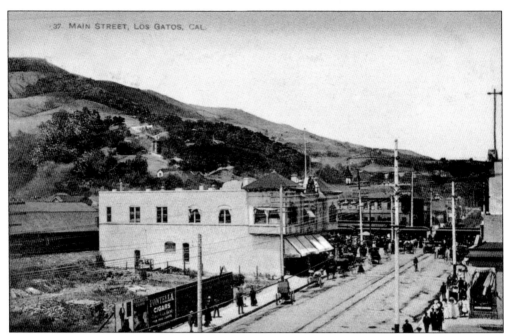

The Rankin Block on the south side of Main Street was built after the October 1901 fire by Clara Rankin, the first female member of the chamber of commerce. The Los Gatos Post Office was located in the lower level of this building from 1917 until 1948.

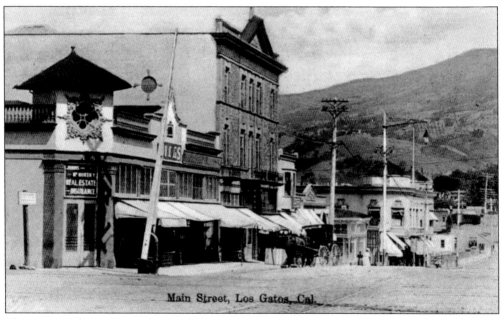

This postcard shows the north side of Main Street looking east. On the left are the railroad crossing barriers, the McMurtry's Real Estate and Insurance office, Ford's Opera House, a horse and buggy, and two nicely dressed women walking toward the Main Street Bridge, which crossed the Los Gatos Creek.

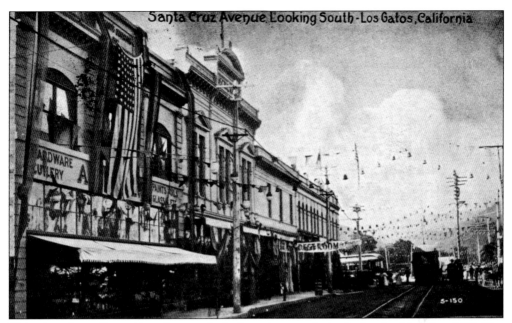

This view shows Santa Cruz Avenue decked out in a patriotic display for May Day 1909. The train and interurban passengers fill the street near the depot, and the banner on the left-hand side announces, "Rest Room for Women." Also on the left and draped with an American flag is the hardware store of Arthur Wellington Bogart.

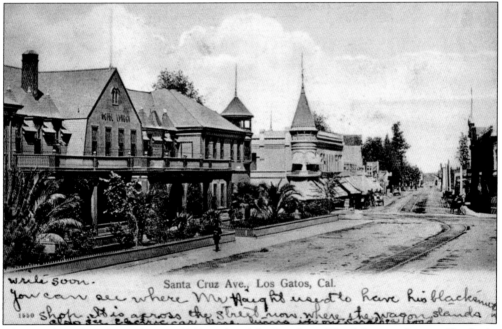

Santa Cruz Ave., Los Gatos, Cal.

The Hotel Lyndon, shown here in 1910, replaced the Los Gatos Hotel that was destroyed by fire in 1898. It was located on a bustling corner of town, directly across Santa Cruz Avenue from the train station. The intersection of Main Street and Santa Cruz Avenue has proved to be a most popular photographic subject over the years.

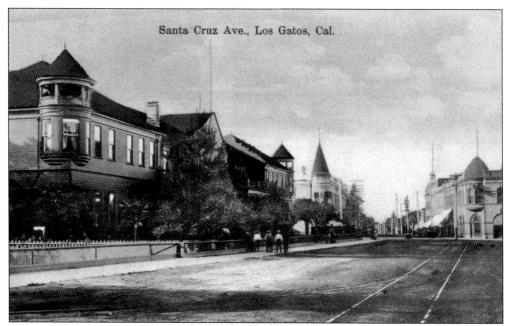

Fire was a major source of destruction for many of the businesses located on Main Street when the town was young. After being rebuilt, a number of them burned to the ground a second time, and gradually the business district shifted west to Santa Cruz Avenue, which ran north and south.

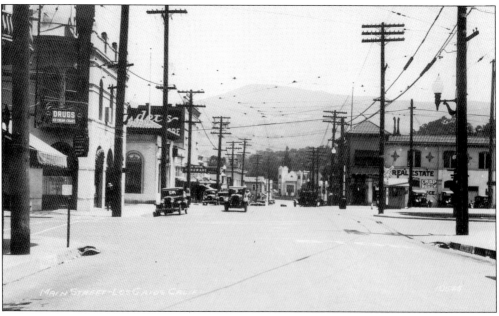

Main Street in the 1920s looks east, with Crider's Department Store occupying the former opera house on the left near Los Gatos Hardware and the Foothill Hotel. Farther down on the right is the very distinctive First Baptist Church. The Crisp and Reilly Real Estate office is in the foreground near the railroad crossing sign warning "look out for the cars" on its post.

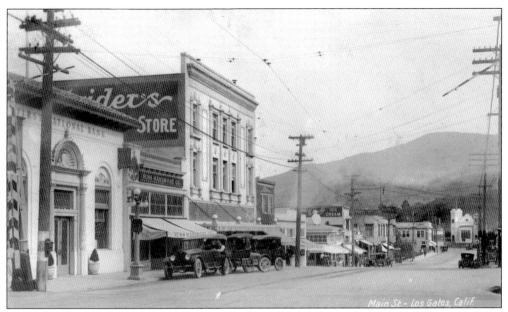

Here is a closer view of Crider's Department Store and the First National Bank Building. J. Walter Crider purchased the Ford Opera House in 1916 and transformed it into a department store, which remained in business until 1957. Promotions for the store included a midget Santa Claus one year and a "human fly" that scaled the building in 1932.

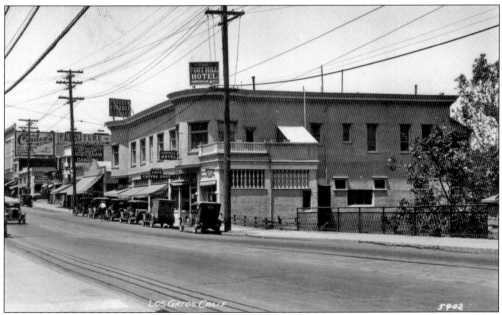

Looking west on Main Street, the Foothill Hotel proudly displays the insignia of the National Automobile Club. In 1925, a single room was $1.50 and a double with bath was $3.50. By this time, the interurban trolley tracks had been removed and automobiles were the preferred mode of transportation. The railing of the Main Street Bridge is visible on the right side of the photograph.

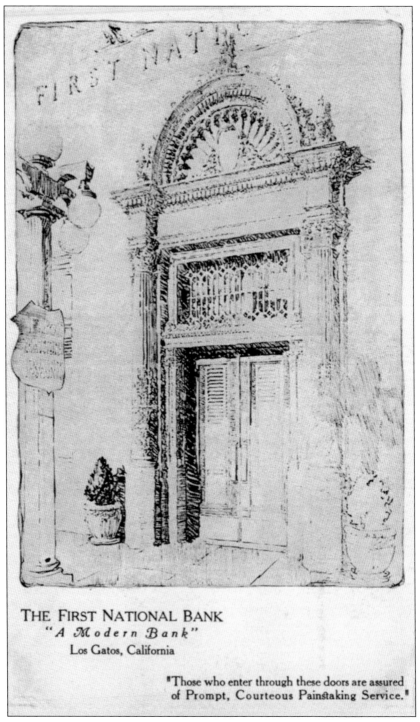

THE FIRST NATIONAL BANK
"A Modern Bank"
Los Gatos, California

"Those who enter through these doors are assured
of Prompt, Courteous Painstaking Service."

This promotional postcard for the new First National Bank assured all who entered "prompt, courteous painstaking service." It was the intention of the bank to construct one of the most modern bank buildings in any town in California. The Renaissance Revival building housed the First National Bank at 160 West Main Street from 1920 until 1955.

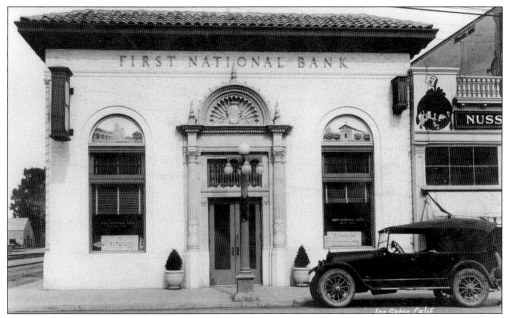

Over 1,500 people attended the grand opening of the First National Bank. Guests received souvenirs including mirrors for the ladies and bonbons for the children. The bank fell victim to the Great Depression in the early 1930s and was reorganized under government regulation. It was purchased by the American Trust Company in 1955.

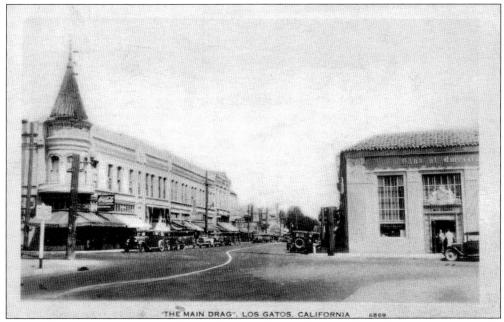

The caption on this postcard postmarked 1936 reads, "The Main Drag." The popular corner of Santa Cruz Avenue and Main Street where the interurban and railroad tracks once crossed had now been given over to the automobile. The impressive building on the right belonged to the Bank of America, and the "witches hat" signature turret of the La Canada building is on the left.

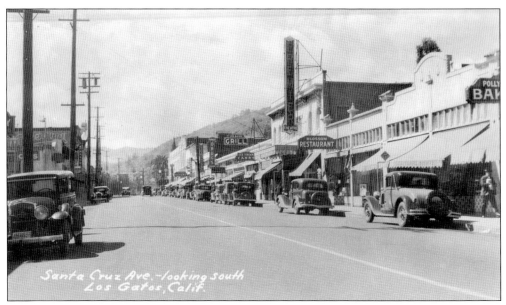

This is a 1930s view of Santa Cruz Avenue looking south toward the Hotel Lyndon. The Premier Theatre halfway up on the right was built in 1916 as a 600-seat silent movie house complete with a Wurlitzer organ. It was subsequently the Strand Theater and finally the Los Gatos Theater. The theater was damaged in a 1929 fire and again during the 1989 earthquake.

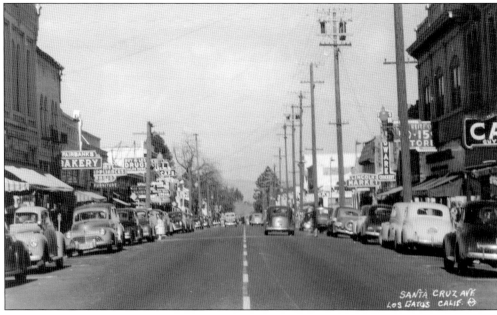

This scene looking north shows a bustling Santa Cruz Avenue with an abundance of shops to chose from. The town that was once focused on agriculture had experienced a postwar boom that doubled the population between 1950 and 1960. The town slogan was, "When you think of home, think of Los Gatos."

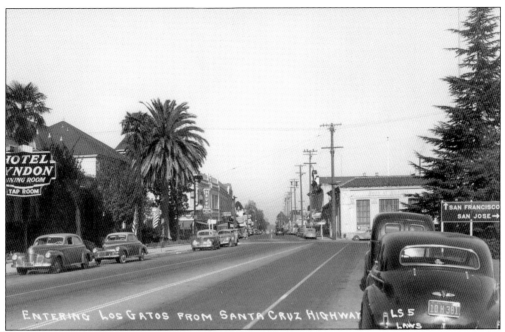

Cars entering Los Gatos from the Santa Cruz Highway would have seen the Hotel Lyndon on their left and the train depot on the right. As the sign indicates, San Francisco would be straight ahead on Santa Cruz Avenue and San Jose would be a right turn on Main Street toward San Jose Avenue.

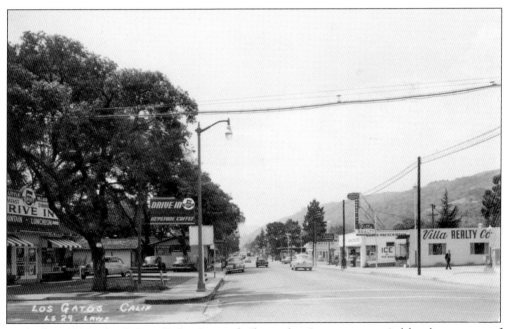

In the late 1930s, the 5-Spot Drive-In was built on the site once occupied by the cottages of the Hunt Brothers Cannery workers. The location on the corner of Santa Cruz Avenue and Highway 9 was the ideal location for the ever increasing number of automobile travelers to stop for breakfast, lunch, dinner, or just a cup of Keystone coffee.

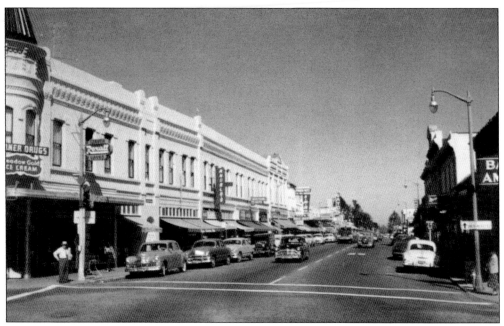

This is a familiar 1950s image of Santa Cruz Avenue at Main Street with the familiar Corner Drugs on the left and the Bank of America on the right. Farther down on the right is the 5-10-15 Cent Store and the Los Gatos Theater. The sign in the foreground on the right indicates that San Francisco is 53 miles straight ahead.

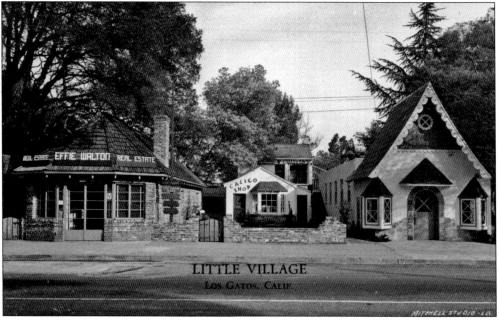

The Little Village shops along Village and Petticoat Lanes were developed in the 1950s by realtor Effie V. Walton on a site that had once been the town cemetery. Effie was the first woman to be president of the Los Gatos Chamber of Commerce and served two terms. She and her husband, Arthur, also developed the Aldercroft Heights neighborhood in the Santa Cruz Mountains in the 1930s.

Greens Pharmacy was founded by George A. Green in 1904 and moved to this location on East Main Street in 1910, where it remained for more than 40 years. Home delivery was available by just dialing "9." Farther down on the right is the First Baptist Church and Reggie's eatery.

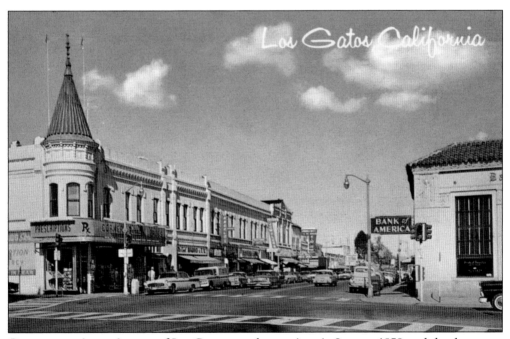

Commuter train service out of Los Gatos ceased operations in January 1959, and the depot was torn down in 1964. Pedestrian crosswalks now occupied the busy corner where the train and trolley tracks once intersected. For 106 years, from 1880 until 1986, Corner Drugs dominated "the elbow" at North Santa Cruz Avenue and West Main Street.

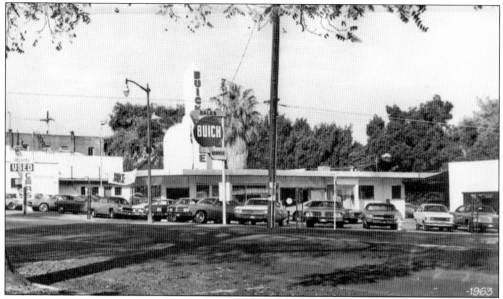

Los Gatos was a great place to open a car dealership. At one time, the town boasted a dozen dealers. One of the three thriving family businesses, and the only one still in operation, is Moore Buick, pictured in 1963 on East Main Street. Ed Moore bought the dealership in 1951 and passed it down to his son and eventually his grandson.

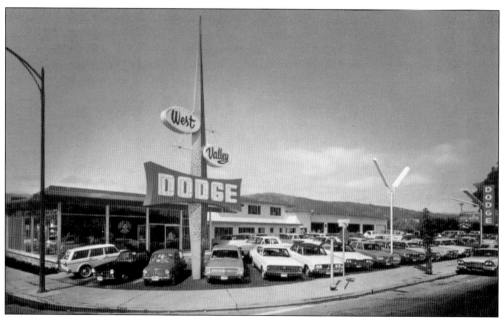

West Valley Dodge had three locations in Los Gatos between 1963 and 1992 and sold Dodge, Fiat, Jeep, Rambler, and Simca automobiles. Simca was one of the biggest automobile manufacturers and most popular automobile brands in France until they were taken over by Chrysler in 1970.

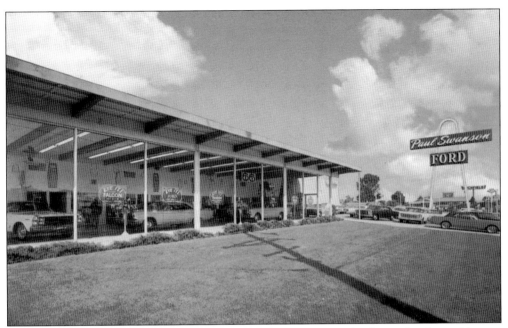

Paul Swanson Ford, later Swanson Ford, was part of the Los Gatos landscape for almost 70 years. Originally opened in 1938 on Santa Cruz Avenue, it later moved to the Los Gatos Boulevard location pictured above in 1966. The McHugh, Moore, and Swanson family auto dealers contributed a sense of community and history to the town.

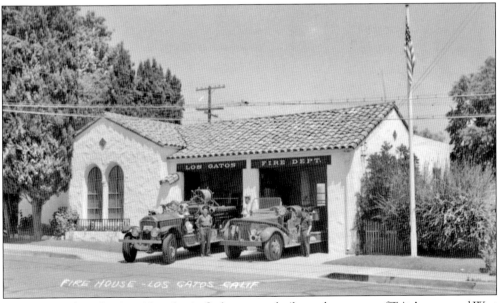

Until 1927, when this Spanish-eclectic firehouse was built on the corner of Tait Avenue and West Main Street, the all-volunteer force kept its equipment in two sheds located on opposite sides of town. The first paid fireman, Bud Lord, lived at the firehouse with his family. The building now serves the community as an art museum.

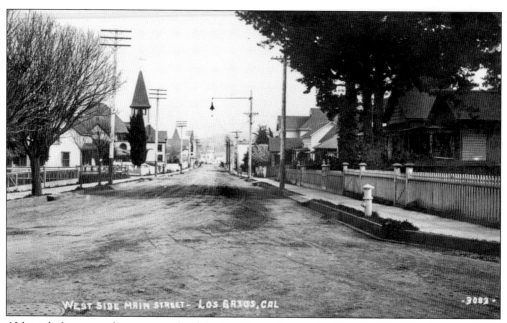

WEST SIDE MAIN STREET - LOS GATOS, CAL -3082-

Although they were disastrous, each of the Los Gatos fires resulted in rebuilding that improved and modernized the town. In 1890, Seanor's Opera House and seven other buildings were consumed by fire. In 1891, ten buildings were destroyed when cartridges exploded in the H. J. Richardson Hardware Store, and on October 13, 1901, almost the entire business district on West Main Street between the bridge and the railroad tracks burned to the ground.

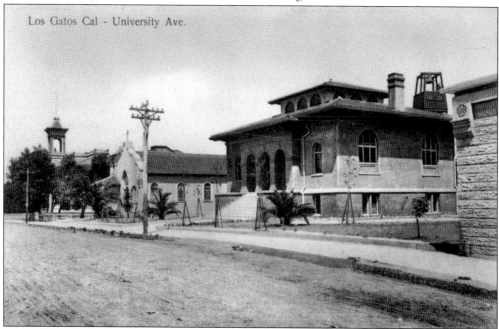

Los Gatos Cal - University Ave.

The town fire bell was damaged when its tower burned in the great fire of 1901. A new steel bell tower was built near University Avenue. The bell and tower are visible in this postcard to the right of the chimney on the Carnegie Library. Though it sustained three cracks when it fell, it remained in service until the 1930s, when it was replaced by a more audible siren.

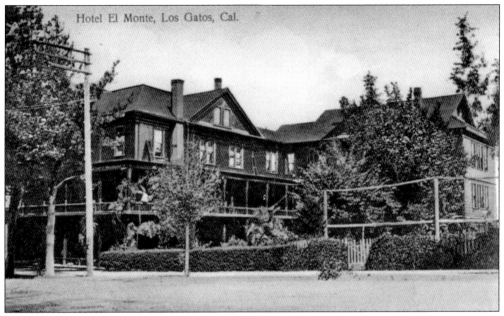

Hotel El Monte, Los Gatos, Cal.

El Monte was the name of the last in a succession of hotels located on the corner of Main and Pleasant Streets between the late 1800s and 1909. El Monte catered to families and advertised itself as positively the only first-class hotel in Los Gatos. Because the structure was made entirely of wood, there was always a danger of fire.

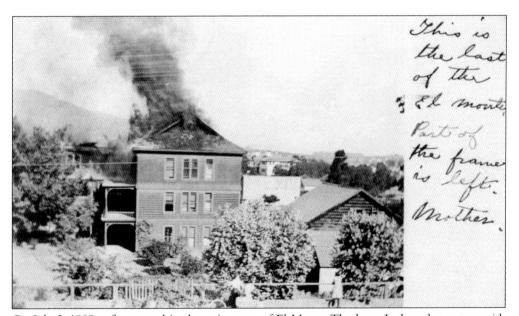

This is the last of the El monte Part of the frame is left. Mother.

On July 3, 1909, a fire started in the attic space of El Monte. The large L-shaped structure with long verandas extending the entire length of the building on all stories was totally destroyed. The message on this postcard reads, "This is the last of the El Monte. Part of the frame is left."

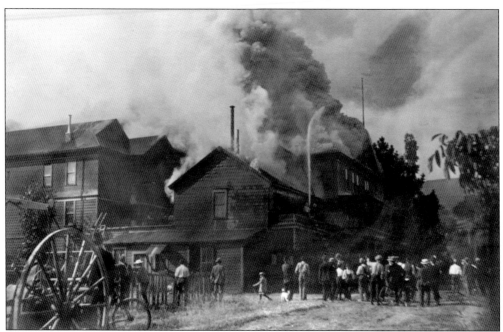

The spectacular El Monte blaze attracted many onlookers and photographers. Fortunately no one was hurt, and most of the furniture was saved. The hotel's owner carried only $5,000 worth of insurance and was never able to rebuild. Replacement costs would have been in the range of $35,000 to $40,000.

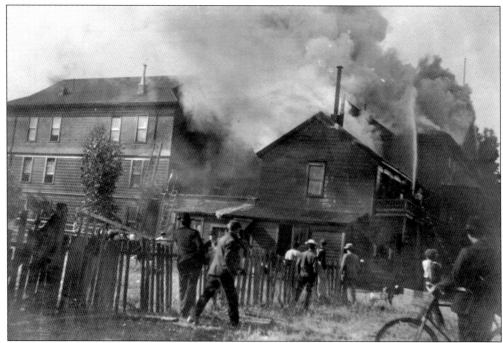

A defective flue in the kitchen at El Monte Hotel was thought to be the cause of the blaze. The heat and smoke in the attic made it impossible for the firefighters to enter the structure, and despite using four streams of water with good pressure, they were unable to save the hotel.

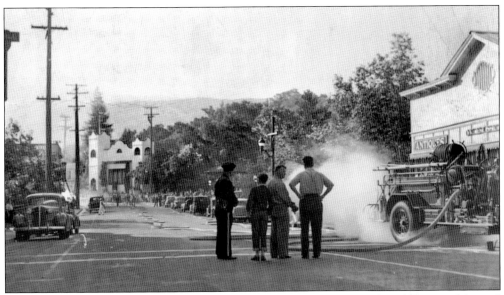

On July 5, 1943, Los Gatos was again devastated when fire broke out in the John F. Good Second Hand Store on East Main Street. Flames enveloped the store and moved eastward, burning the rear of the Lewis Plumbing Shop and a large garage building and its contents.

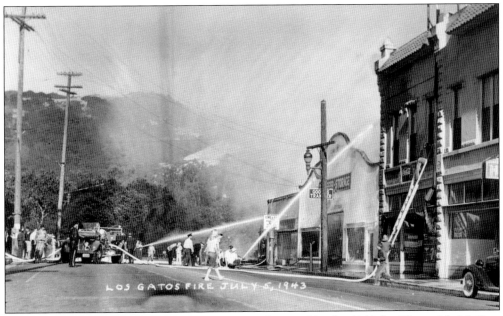

Lewis and Son's and several other buildings were destroyed in the 1943 fire. The red-brick Rex Hotel, once home to the town post office, sustained considerable damage. The Rex was constructed following the 1891 fire and was scorched in the 1901 fire. Property damages this time exceeded $50,000, but the loss of personal property was immeasurable.

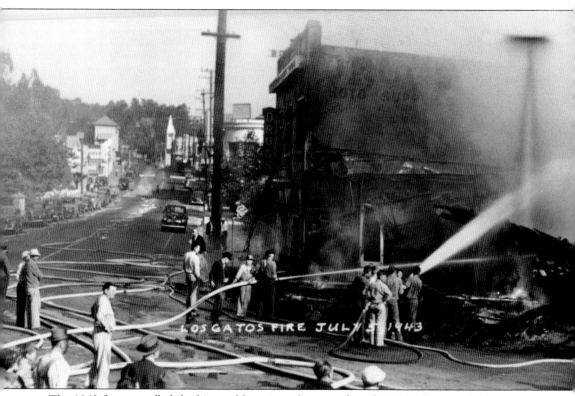

LOS GATOS FIRE JULY 5 1943

The 1943 fire was called the biggest blaze since the great fire of 1901 and covered the same area ravaged by the 1891 fire. Buildings that had survived the earlier fires were lost in this blaze. One fireman was injured when he drove an ax into his foot while cutting a hole through the roof of one of the burning buildings.

Six

TOWN LIFE

This vintage postcard highlights a selection of the impressive architectural styles found in Los Gatos and reflects the pride of the town. The University Avenue School, Hotel Lyndon, Main Street Bridge, St. Luke's Church, Carnegie Library, and the Methodist church are joined by the official state flower, the California poppy.

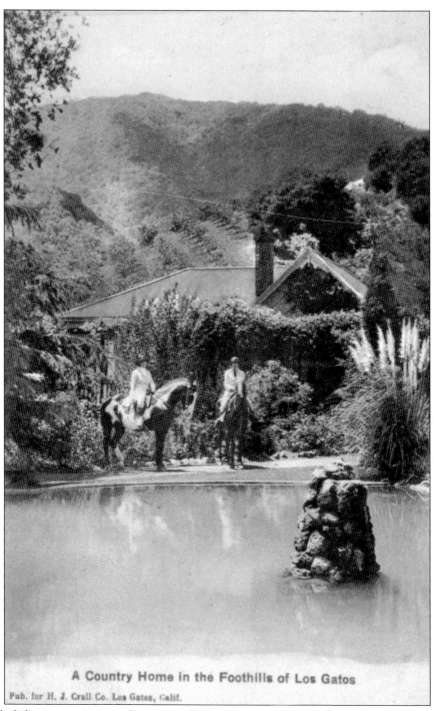

A Country Home in the Foothills of Los Gatos

Pub. for H. J. Crall Co. Los Gatos, Calif.

The ideal climate, proximity to the coast, and cultural atmosphere of Los Gatos were very attractive to those searching for the perfect spot to call home. Business entrepreneurs were expanding the commercial section of town, and the residential areas began to extend farther out. When the "Almond Grove" addition was marketed in 1887, special trains brought potential buyers in from San Francisco, and 121 lots sold the first day.

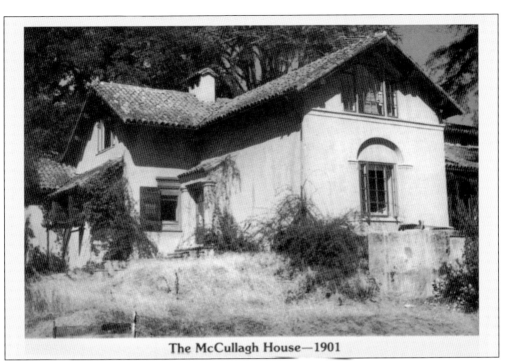

The McCullagh House—1901

Frank McCullagh moved to Los Gatos in 1880 and purchased 166 acres of land. He donated one-quarter acre of Fairview Plaza to the Camp Fire Girls in 1927. In 1973, developers proposed tearing down his 1901 mission revival–style home, but they were denied by preservationists. It has been beautifully restored by the present owners.

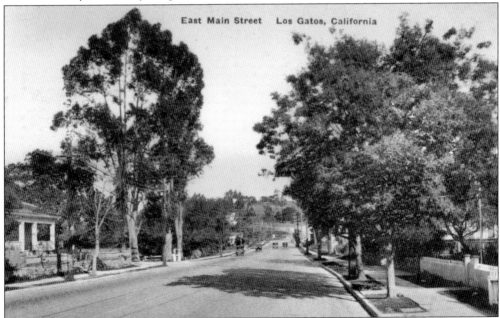

In 1852, the site of the future town of Los Gatos had only one adobe hut. By 1859, the flour mill and two shanties for the mill laborers had been built. In 1862, the first dwelling house was built on the corner of Mill and East Main Streets, and by 1881, the town consisted of at least 100 families.

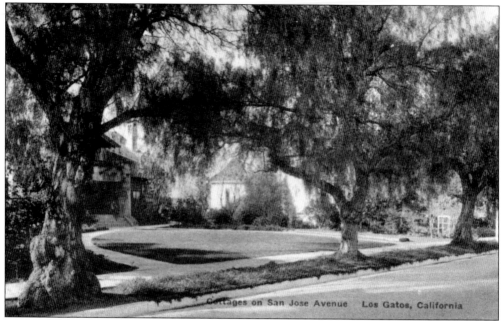

This is a view of cottages on San Jose Avenue, which, in 1880, extended all the way down to the east bank of the Los Gatos Creek. There were farm houses built near the road on the higher ground, reserving the more fertile bottom land at creek level for the agricultural crops and fruit trees.

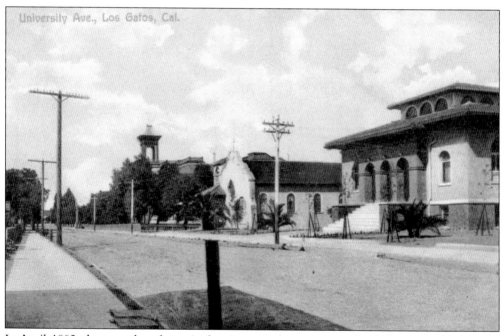

In April 1902, the town board acquired a site near the grammar school for a new library. The Carnegie Foundation had agreed to donate $10,000 toward the building on the condition that the town would pay at least $1,000 a year for its upkeep. The new library was built next to St. Luke's Episcopal Church on University Avenue and opened its doors in September 1903.

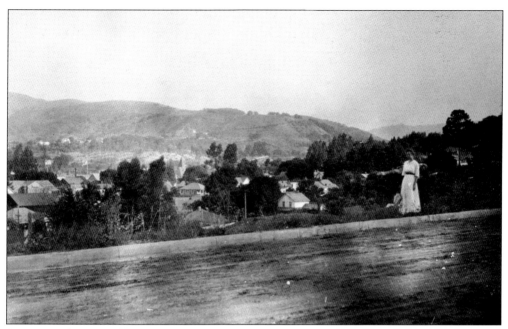

Argie Ross is pictured here in 1907 on Glen Ridge Avenue overlooking the town of Los Gatos. In 1909, an article in the local paper revealed that Los Gatos had more houses contemplated and under contract than any other town of its size in California. Buyers were warned not to ignore real estate agents thinking they would save money by dealing directly with home owners.

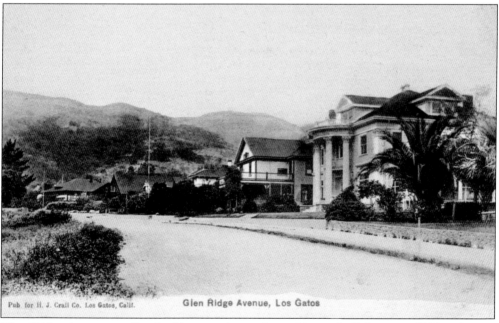

Pub. for H. J. Crall Co. Los Gatos, Calif. Glen Ridge Avenue, Los Gatos

Glen Ridge Avenue was lined with many impressive residences built between 1890 and 1910. The stately Colonial on the right was built in 1908 by a businessman from North Dakota for his retirement. J. Walter Crider, proprietor of Crider's Department Store on East Main Street, purchased the home for his family in 1920. The exterior remains virtually unchanged, and replacements for the original marble lions guard the entrance.

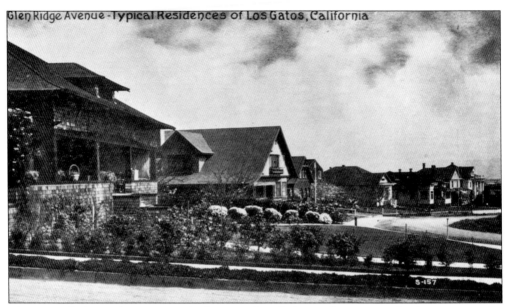

This view of Glen Ridge Avenue is looking north with the Crider mansion five houses up on the left. The shingled Craftsman-style house on the corner of Glen Ridge and Hernandez Avenues was built in 1910 by E. E. Pomeroy.

This postcard shows one example of many Los Gatos homes built between 1903 and 1920. The style is a combination of neoclassical and Craftsman. Neoclassical cottages share many characteristics with Craftsman-style houses and utilize comparable materials and similar design details.

This much simpler Craftsman-style cottage could have been purpose built as a rental in the early 1900s. A number of prominent townspeople owned multiple investment properties in the town. In April 1885, the Los Gatos Gas Company completed its plant and lit the town for the first time. Not until 1896 were the remainder of the streets all illuminated.

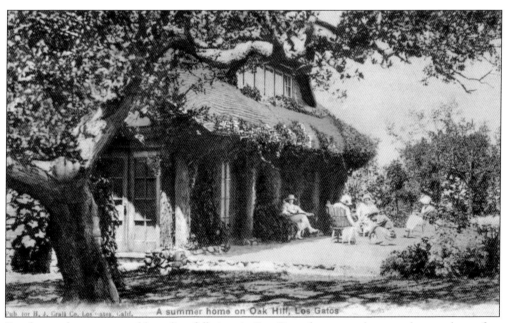

For those who were not able to live full-time in Los Gatos but wanted to spend more than a few days, the area was the ideal location for a summer retreat. Many San Francisco families traveled down to escape the cold, foggy weather of the city. The journey was convenient, and the natural beauty of the area was conducive to relaxation.

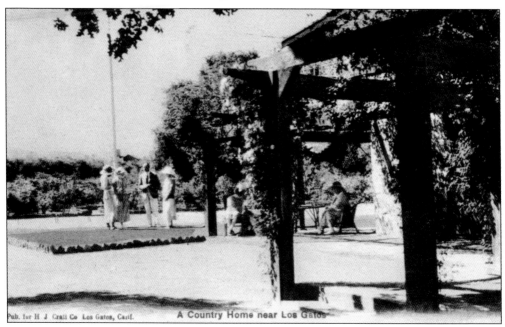

A Country Home near Los Gatos

Many country homes were located in the hills surrounding Los Gatos. The image suggests that a stylish lifestyle was enjoyed by the residents living above the town. This postcard was published for the H. J. Crall Company in Los Gatos. The business established by Henry Jewett Crall in 1891 was operated by four generations of his family, in three different Los Gatos locations, until 1981.

Something Going to Occur

The Floral Carnival and Feast of Lanterns were part of the May Day celebrations on May 7, 1909. More than 20,000 people attended this successful event, organized by the Los Gatos Board of Trade. Never before had so many automobiles come together to witness a show in California; some arrived days before to enjoy the bright warm weather.

84

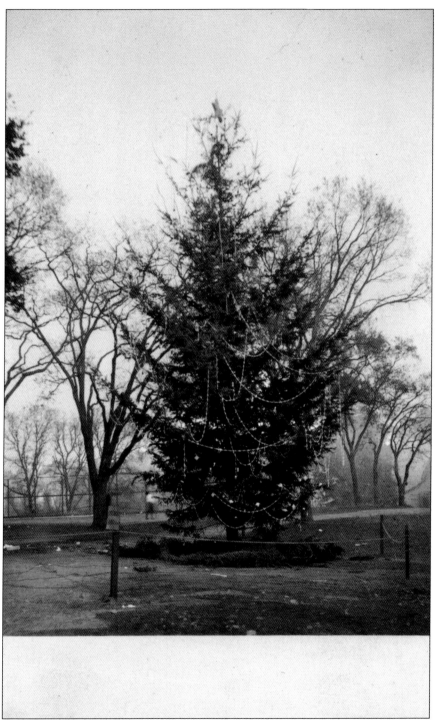

In 1923, the History Club of Los Gatos planted a deodar cedar in Lyndon Plaza, promising that it would grow in size along with the population of Los Gatos. By 1988, the population of the town was approximately 28,000, and the tree was 70 feet tall and 40 feet around the base. The traditional lighting ceremony in early December each year remains a popular community event.

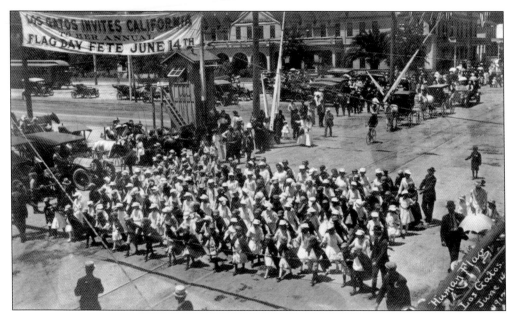

Los Gatos was a culturally active town from its beginning. Theater, opera, and lavish holiday celebrations filled the calendar. Pictured here is a "human flag" consisting of approximately 100 women dressed in red, white, and blue during the Flag Day fete on June 14, 1912. The impressive Hotel Lyndon on Santa Cruz Avenue stands in the background.

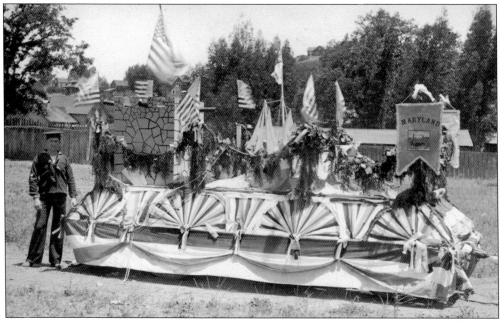

Los Gatos led all cities and towns in the land of the free, the greatest nation on earth, in celebrating the adoption of the stars and stripes as the national emblem of sovereignty. Pictured is the float representing Maryland during the town's second annual observance of Flag Day on June 13, 1913.

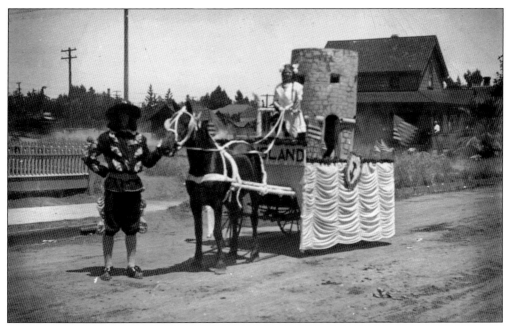

The 13 original states were represented by 13 young ladies on horseback on Flag Day in 1913. The states themselves, which had come from the Louisiana Purchase, were represented by elaborate floats such as this one for Rhode Island.

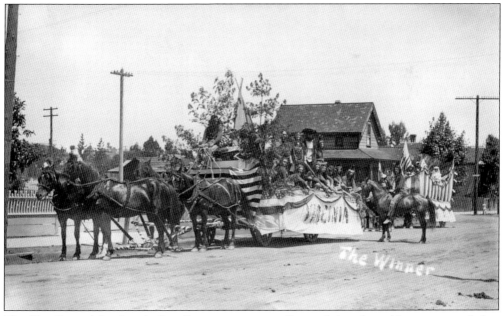

The Flag Day celebrations in Los Gatos were very well attended, and trophies were awarded to winning floats, such as this one representing Virginia, one of the original 13 states. In 1916, Pres. Woodrow Wilson issued a proclamation that officially established June 14 as Flag Day. In August 1949, National Flag Day was established by an act of Congress.

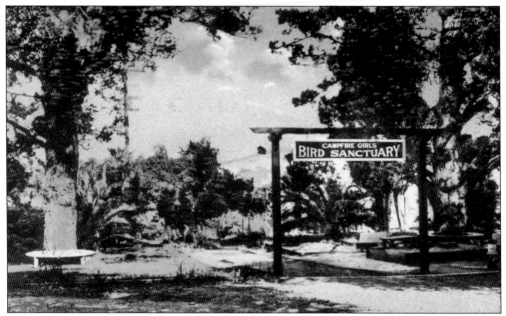

In 1927, the Camp Fire Girls chapter known as "Wawataisa" reclaimed a one-quarter-acre park, Fairview Plaza, which had been donated to the town by Frank McCullagh. Much of the community became involved in the project that transformed one-third of the park into a playground and the remainder into a bird sanctuary.

Rose Bush, Fairview Plaza, Los Gatos, Cal.

Fairview Plaza was covered with weeds, dead wood, and overgrown rosebushes when the Camp Fire Girls took it on as a project in 1927. The girls pulled weeds, raked leaves, and pruned the rosebushes. They built and painted birdhouses for the sanctuary, and when the charming little park was complete, there were Japanese-style gateway arches and a lily pond donated and constructed by town volunteers.

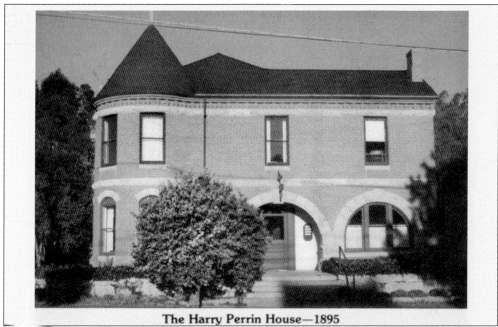

The Harry Perrin House—1895

Harry Perrin was a brick mason who completed construction of what was to be his family home prior to his wedding. This example of a traditional "honeymoon house" originally had no electricity but was fitted for gas lighting by way of piping within the brick walls. Perrin also participated in the construction of the fortifications for the San Francisco Presidio.

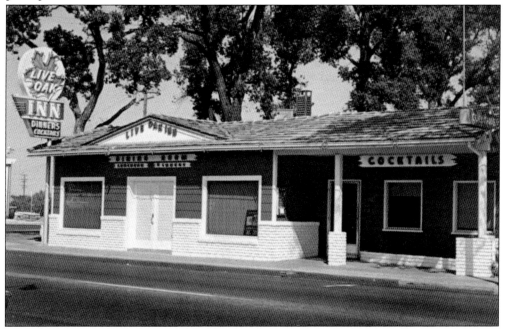

The Live Oak Inn was located in the Little Village development on Santa Cruz Avenue, which was built between 1945 and 1950. The inn was the site of a reception held to celebrate the 75th anniversary of Los Gatos, when Lt. Gov. Glenn Anderson commended the town for retaining its intrinsic charm and beauty.

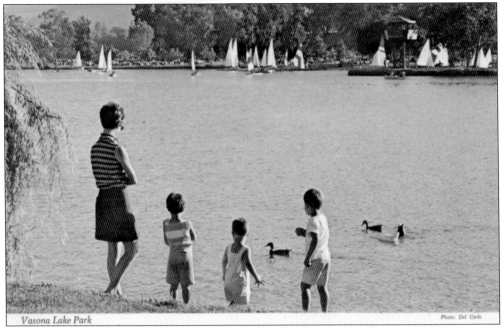

Vasona Lake Park Photo: Del Carlo

Vasona Lake was created in the 1950s by damming Los Gatos Creek. The land within the park's boundaries is among the most historic in Los Gatos. The grantees of the Rancho Rinconada de los Gatos, Jose Hernandez and Sebastian Peralta, constructed an adobe house on what is now one of the park's lawns. The lake is a great place to watch wading herons, Canadian geese, and paddling ducks.

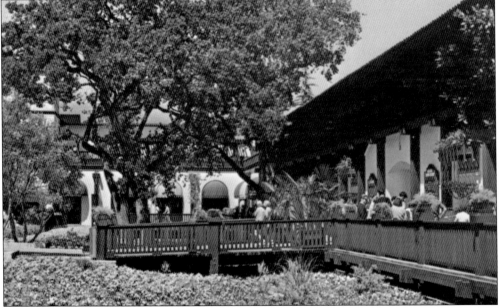

In the 1960s, local businessman Max Walden dreamed of a Los Gatos known throughout the state as a center of art and culture and early California history. The result was a $6 million development on University Avenue designed to recapture the early California Spanish atmosphere of the San Juan Batista Mission.

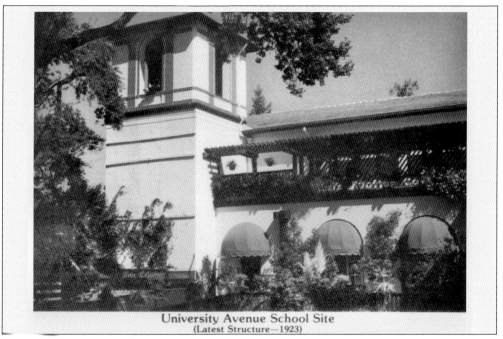

University Avenue School Site
(Latest Structure—1923)

The original Victorian schoolhouse building served until 1925, when the mission-style complex replaced it. University Avenue was so named because it sounded more prestigious than School Street. The 1960s Old Town development maintained the mission character.

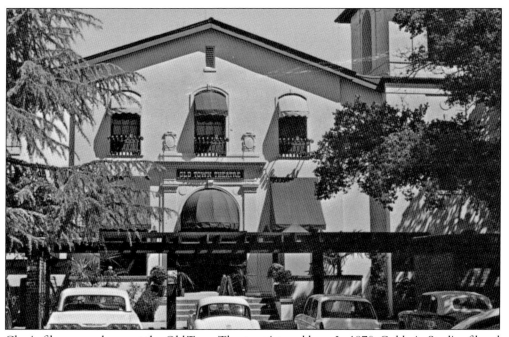

Classic films were shown at the Old Town Theatre, pictured here. In 1970, Goldwin Studios filmed *The Toy Factory* in and around the Old Town area. The star of the movie, Orson Welles, spent one night at the Los Gatos Lodge during the shoot. When the first Los Gatos Summer Festival was held in Old Town in 1967, over 85,000 people attended.

Old Town was a showplace for arts, crafts, and cultural development. A 1967 survey taken in Old Town reported that 49 percent of the visitors were from outside the immediate area. A majority of those surveyed were shopping or were there to eat, and a small number were on business. Ninety-six percent said they had arrived by private automobile.

Seven

THE MOUNTAIN COMMUNITIES

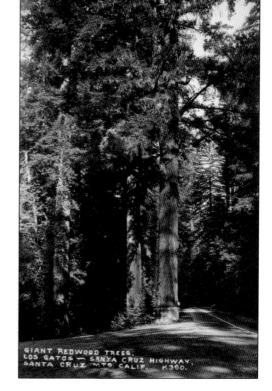

The coastal redwood trees that populate the Santa Cruz Mountains above Los Gatos have always held a certain fascination. In the 19th century, their lumber was prized and they were greedily harvested without regard for conservation. As the area was settled by those with an appreciation for the natural environment, these majestic giants became not only an attraction but an asset to the growing community.

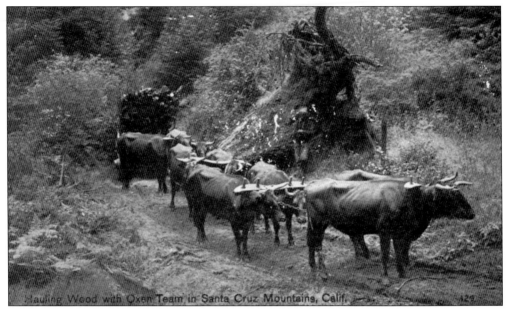

Hauling Wood with Oxen Team in Santa Cruz Mountains, Calif.

In 1847, the first sawmill was built in the mountain town of Jones Mill, located 3 miles above Los Gatos. By 1867, the town, renamed Lexington, boasted eight lumber mills, a hotel, livery, and blacksmith. The population, once larger than that of Los Gatos, declined as local lumber was depleted and the sawmills were forced to move deeper into the mountains.

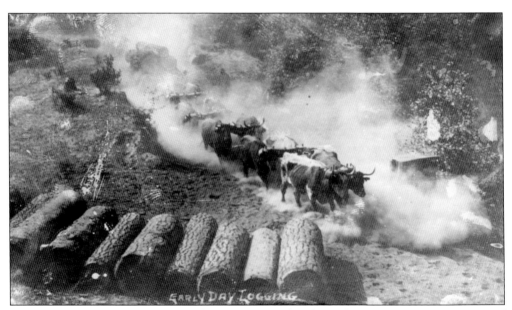

EARLY DAY LOGGING

When logging activity was at its peak, there was a load of lumber either coming into or going out of Los Gatos every 15 minutes, 24 hours a day. When the lumber mills moved over the ridge to more lucrative sites, Los Gatos was no longer the hub of the transportation and distribution system.

94

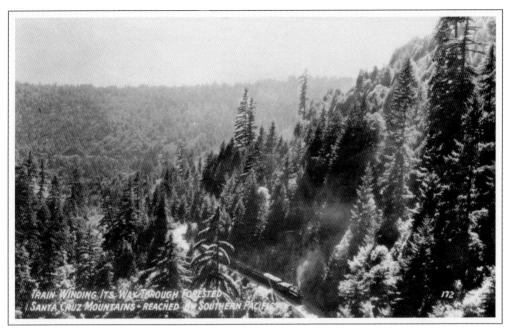

The railroad reached Los Gatos in 1878 and continued to penetrate deeper into the Santa Cruz mountain range as the route to the coast became a reality The towns of Lexington and Alma, located one mile farther south, accommodated railroad engineers, bridge builders, track layers, and an increasing number of tourists. By 1887, there were numerous hotels and guest houses, and 12 saloons lined the mile between the two towns.

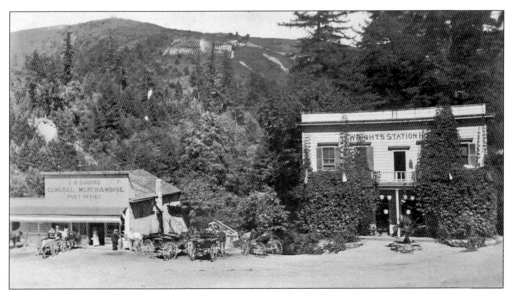

Wrights Station was built on property belonging to the Reverend James R. Wright. It was the center of activity for mountain orchardists shipping their produce to the valley canneries and many finely dressed weekend passengers making their way to Sunset Park, Glenwood Magnetic Springs, and Skyline Park for picnics and fresh mountain air.

This "cosy house in the Santa Cruz Mountains" was located near the community of Wrights, which had a depot, hotel, store, post office, blacksmith shop, and a number of Chinese stores and washhouses operated for the railroad workers. It was also the home of the infamous Tunnel Saloon.

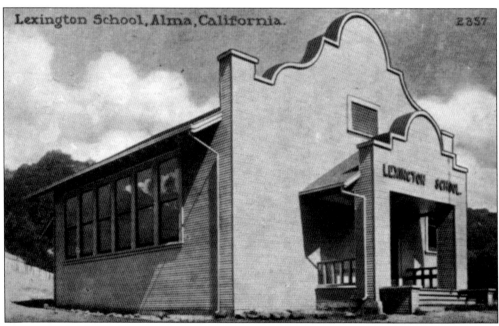

Founded in 1859 and located in Alma, the Lexington School was the first school established in the area. The building was moved and a second classroom was added in 1928. The school reopened in its present location in 1953. John Pennell Henning founded the community of Lexington and named it after his former hometown in Missouri.

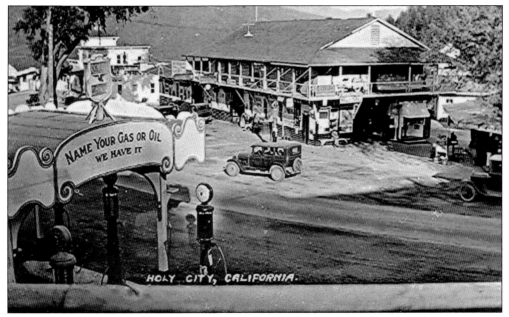

In 1919, William E. Riker founded a community just above Lexington, which he called Holy City. His intention was to establish the seat of the world's most perfect government. Riker built a lodge, restaurant, gas station, radio station, and a newspaper office. There was also an observatory with huge telescopes.

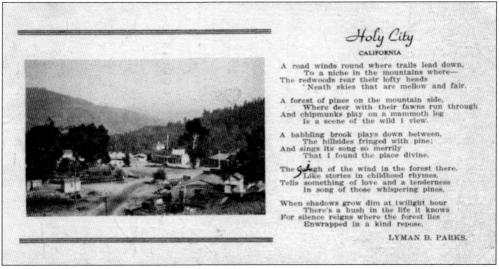

Riker's dream attracted impressionable people to the garish-looking town for a time, but his followers eventually became disenchanted with Riker's ranting and drifted away. When the Santa Cruz Highway was rerouted, the town of Holy City faded into obscurity.

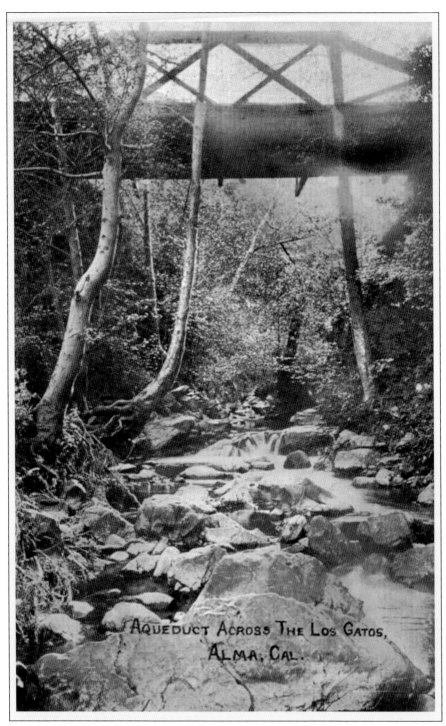

AQUEDUCT ACROSS THE LOS GATOS,
ALMA, CAL.

The town of Alma was described as "the Switzerland of America," and as word spread, more and more people came for the health effects of the local soda springs. The weekend and holiday picnic trains carried lively, happy crowds up the hill to the mountain resorts in the morning and tired, dirty travelers back down at night.

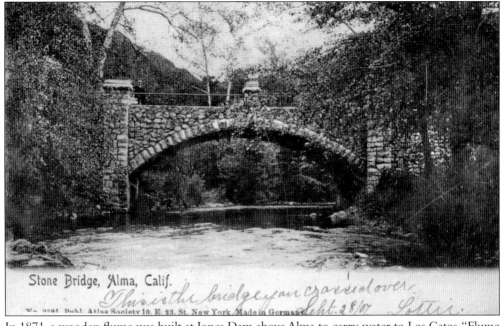

Stone Bridge, Alma, Calif.

This is the bridge you crossed over. Sept. 28/07 Lottie.

No. 9991 Publ. Atlas Society 10. E. 23. St. New York. Made in Germany.

In 1871, a wooden flume was built at Jones Dam above Alma to carry water to Los Gatos. "Flume walking" was a popular activity for courting couples, but frequent encounters with wildcats and skunks were far from romantic. The wooden structure was replaced by a galvanized steel aqueduct in the 1930s.

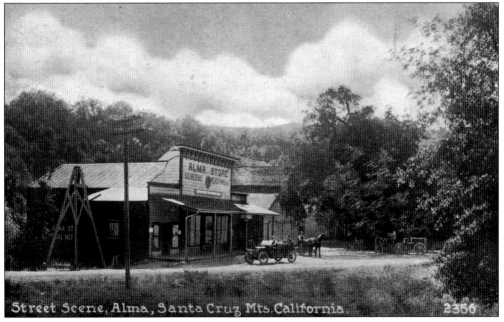

Street Scene, Alma, Santa Cruz Mts. California. 2356

Alma was an important stagecoach stop, lumber mill site, and active train depot for freight and passengers in its heyday. The 1906 earthquake closed the rail system to over-the-mountain traffic for three years, which devastated the little town. Eventually the Los Gatos Creek depository was considered an ideal location for a reservoir, and in 1952, what had been the communities of Lexington and Alma disappeared underwater.

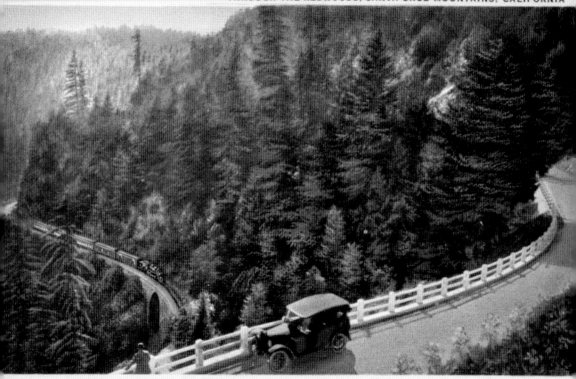

Interstate highways for automobiles allowed people to travel farther from home. In 1921, the highway connecting Los Gatos and Santa Cruz was cut and widened and set in a thick layer of concrete. In 1939, the road was widened to four lanes, renamed Highway 17, and now bypassed most of the scenic and historic communities that had made it so interesting.

Eight

Transportation and Tourism

Horses, buggies, wagons, and stages were the earliest modes of transportation in Los Gatos. A trip across the mountains could take hours, and the likelihood of encountering bears, bandits, and mountain lions was almost a certainty. Those who came seeking their fortune in mining soon discovered another golden opportunity in the timber of the coast redwoods.

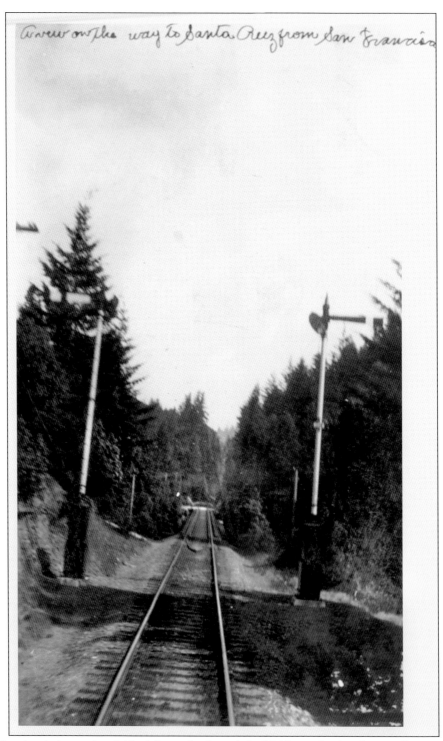

The logging industry, the yield of the orchards, and the highly productive flour mill necessitated the continuation of the railroad line from San Francisco to Santa Cruz. During the peak of the logging activity, the trains operated 24 hours a day.

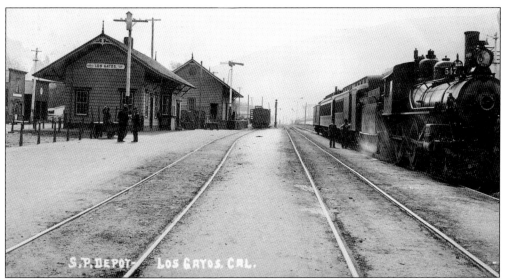

Constructing the broad-gauge line to Santa Cruz was an incredible challenge. Bridges needed to be strengthened or rebuilt, tunnels blasted, and curves widened. Unfortunately, the 1906 earthquake caused major damage, interrupting service for approximately three years. This 1910 image shows the standard-gauge track, which reopened the line in May 1909.

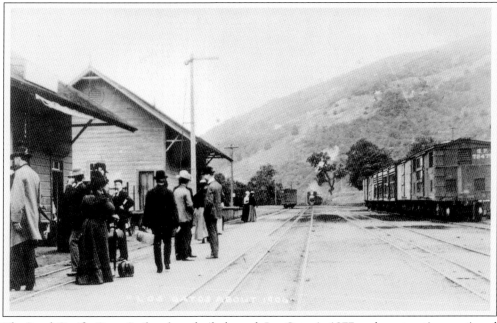

The South Pacific Coast Railroad was built through Los Gatos in 1877, and construction continued on the line through the Santa Cruz Mountains toward the coast. That same year, passenger service to San Francisco was made available. This image shows the train approaching the depot from the coast to collect well-dressed passengers traveling north.

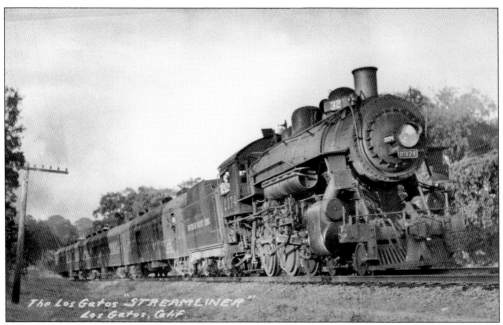

This postcard mistakenly identifies local Santa Cruz train No. 32 as the "Los Gatos Streamliner" in an early-20th-century image. The *Streamliner* did make one brief appearance in Los Gatos in the winter of 1956 during a test run on the San Francisco–to–Los Gatos route.

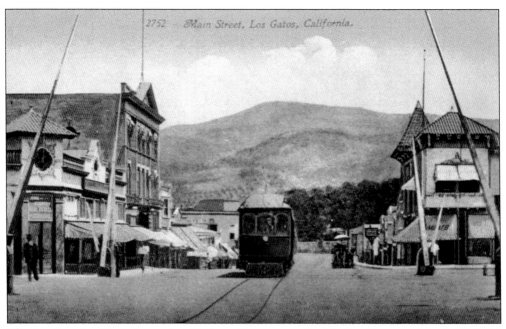

The San Jose–Los Gatos Interurban Railway Company arrived in Los Gatos on March 19, 1904. When Southern Pacific purchased the company, which was reorganized as the Peninsular Railway in 1909, the rail service for passengers between San Francisco and Santa Cruz was greatly improved by linking a number of smaller towns along the route.

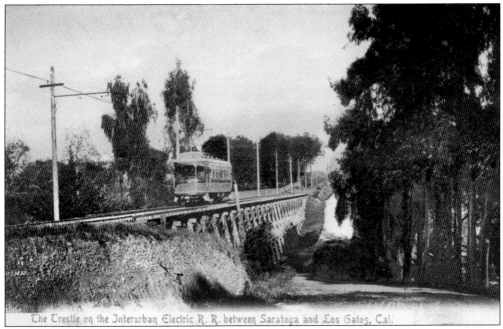

The interurban cars were highly unstable and often likely to jump the tracks. During the rainy season, wet leaves created a slick surface, and in the early days of the service, young boys would jump on the cars and try to shake them off the tracks. Surprisingly, only one fatality occurred in the 30-year history of the Peninsular Railway in Los Gatos.

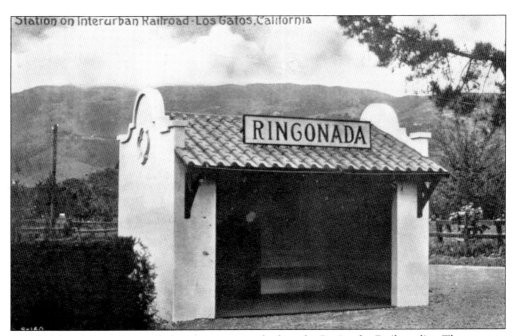

Pictured here is a mission revival–style passenger shed on the Peninsular Railway line. The message on the card dated May 26, 1915, describes this as the closest electric stop to where the writer is staying. *Rinconada* is Spanish for "corner."

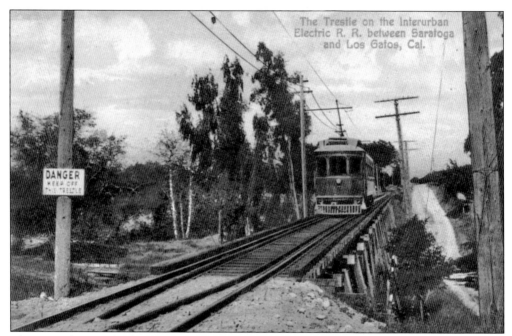

The interurban tracks fed into the Los Gatos depot, where the trolleys would lay over beside the Southern Pacific Coast trains. As the roads improved and the number of buses and private automobiles increased, the electric train business declined. In 1933, the last trolley left Los Gatos to the delight of those who considered it an obsolete means of transportation.

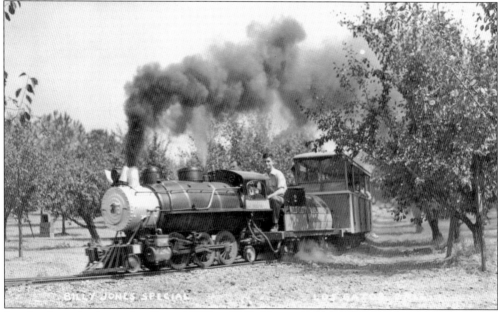

Local train enthusiast and collector William "Billy" Jones (1884–1968) rose quickly through the ranks of the South Pacific Coast Railroad. He established the Wildcat Miniature Railroad on his ranch in Los Gatos and for 25 years delighted passengers of all ages. After his death, the train was refurbished and relocated to Oak Meadow Park, where it continues to provide a link to the past and a tribute to this great man.

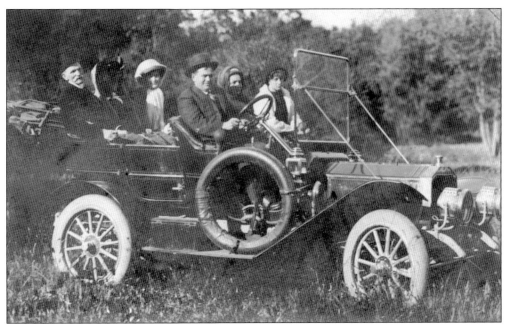

Some townspeople lamented the loss of the interurban trolley, but most embraced the automobile as a much more convenient mode of transportation. As early as 1915, traffic at the Main Street and Santa Cruz Avenue intersection was creating a problem. Vehicles would "cut" the corner into the path of the Peninsular Railway cars, resulting in serious accidents.

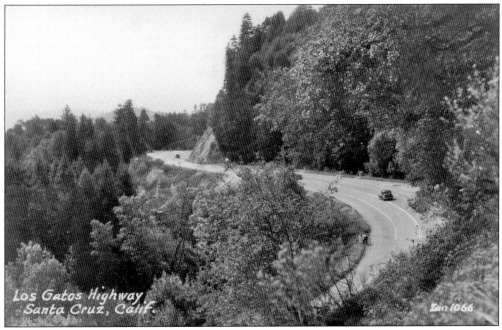

Los Gatos Highway, Santa Cruz, Calif.

With the increased popularity of private automobiles, and the demise of commuter train service from Los Gatos to Santa Cruz in 1940, the amount of traffic over the mountains to the coast was on the rise. The dirt and gravel road was paved in 1921, and approximately 8,000 automobiles were counted on the opening Sunday.

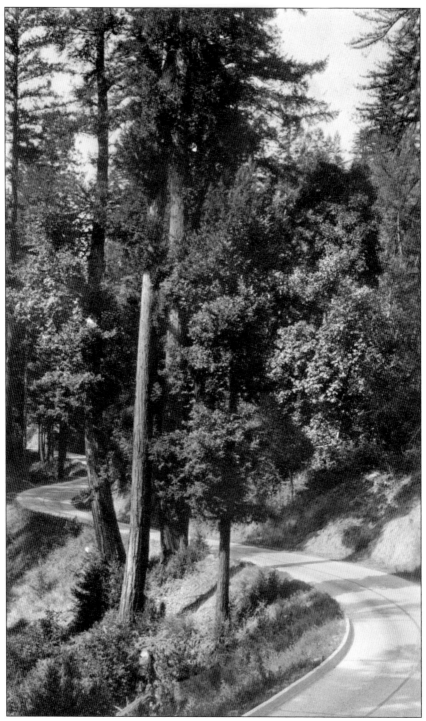

The 16-foot-wide Santa Cruz Highway, constructed of Portland cement, was opened to traffic in 1921. Paving was funded by a state bond measure passed in 1911 at a cost of $39,000 per mile. The cement was a cleaner and safer surface for drivers than the dirt and gravel road that preceded it, but negotiating the curves was still problematic.

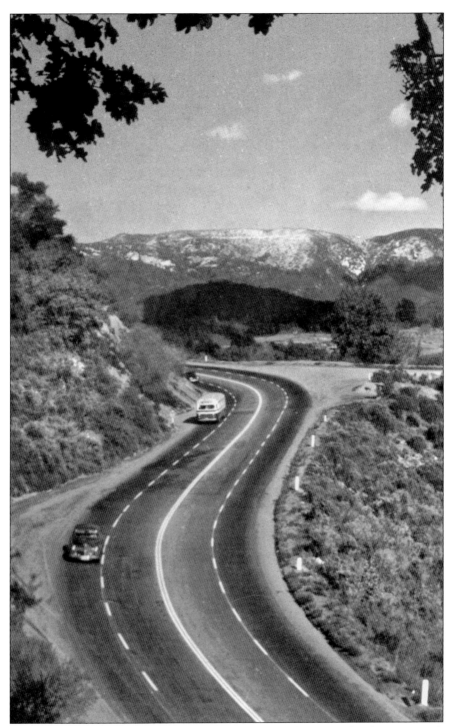

A traffic report in July 1937 estimated that 14,000 automobiles drove the dangerous twists and turns of the mountain highway in just 16 hours. The need to upgrade was obvious, and by 1939, the road was upgraded to four lanes of macadam and the number of curves was reduced. The mountains appear to have a dusting of snow, which is always a pleasant surprise when it occurs.

My Vacation Address Is
Los Gatos
California

The town of Los Gatos has been a popular destination for more than a century. Some visitors came from far away, but many were residents from valley towns nearby who came to escape the summer heat. These visitors enjoyed the idyllic climate no matter what the season and the many recreational opportunities available.

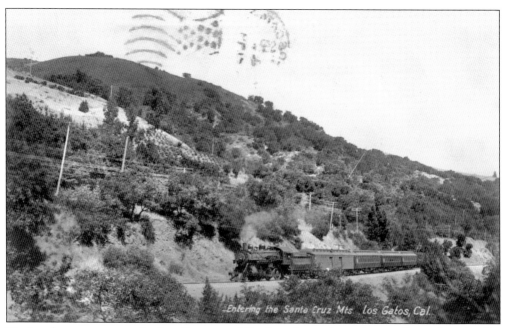

Entering the Santa Cruz Mts. Los Gatos, Cal.

During the summer months, Los Gatos was full of tourists and vacationers. Every Saturday, big excursion trains came down from San Francisco and Oakland. To entertain passengers who disembarked in Los Gatos, there were marching bands and parades that wound up at the town park. Sportsman trains departed town late on Sunday afternoons bound for mountain lodges.

This postcard published by the San Jose Chamber of Commerce highlights just a few of the many area attractions. The inclusion of the Big Trees area of Henry Cowell Redwoods State Park indicates how popular the redwoods were. The Santa Cruz and Felton Railroad has been carrying passengers to the Big Trees and the beach since 1875.

Excursion trains would stop in Los Gatos and then continue up the mountains to Wrights, Laurel, and Glenwood. The combination of sunshine, fresh air, and large quantities of food and drink resulted in what was sometimes a frightening return trip for the crews. Occasionally, inebriated passengers would jump, fall, or be pushed from the moving platforms between the cars.

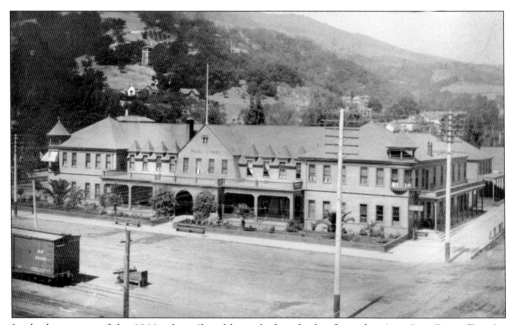

In the latter part of the 1800s, the railroad brought hundreds of travelers into Los Gatos. Despite the fact that there had been a large hotel located across from the depot for a number of years, the local press expressed their expectation that a good hotel, able to accommodate 200 guests, would be built.

Picnic grounds, spas, and resort hotels were plentiful in Los Gatos and the Santa Cruz Mountains beyond the town. The local parks celebrated most of the significant historical occasions and national holidays with pageants and parades, and residents and visitors alike enthusiastically participated.

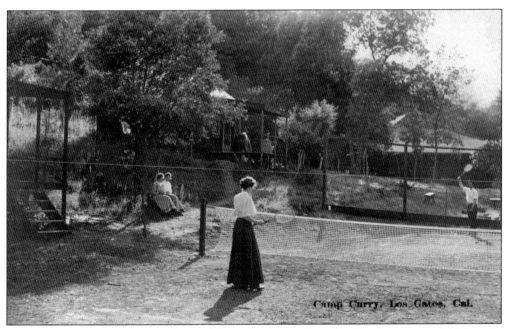

Camp Curry was located in Lyndon Gulch south of town. Four furnished cottages and 33 "mostly new" tents were available for rent. This postcard was mailed in June 1909, just after the camp opened for the season. It was printed by Robinson and Crandall of Palo Alto, California.

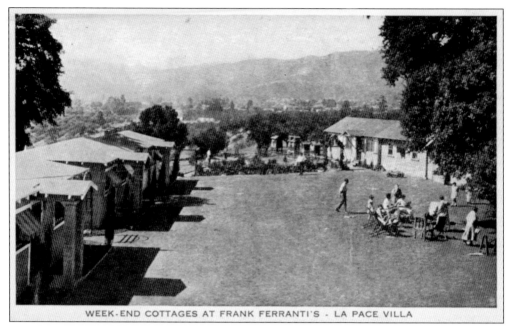

WEEK-END COTTAGES AT FRANK FERRANTI'S - LA PACE VILLA

Frank Ferranti's La Pace Villa weekend cottages and restaurant were located north of Los Gatos on Winchester Road. "A good pace for your summer vacation," suggested the playful caption on this postcard mailed in 1939.

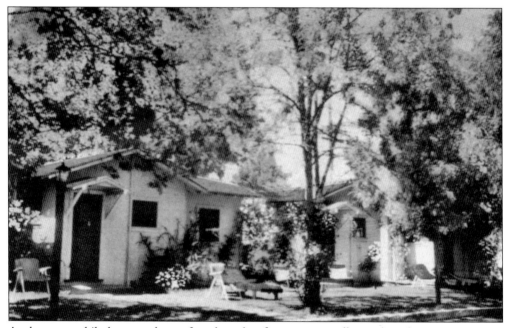

As the automobile became the preferred mode of transport, small motels and vacation cottages offered travelers a more economical alternative to big hotels. According to the caption on the back of this postcard, Fannings Motel was located in "California's paradise, where people choose to live" with an elevation of 400 feet above sea level and a population of 5,300.

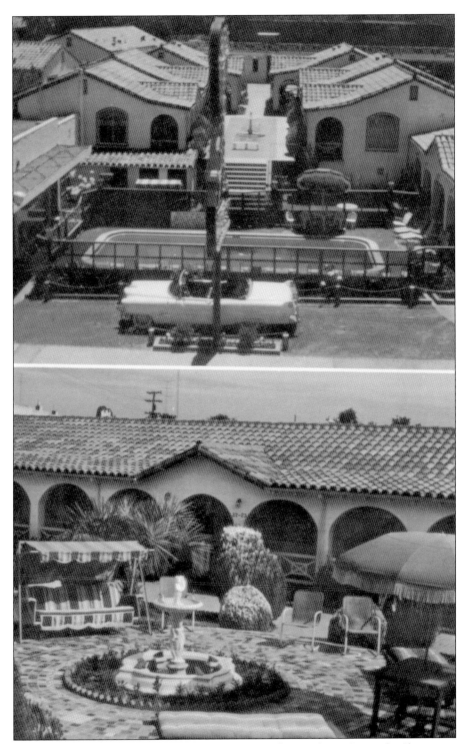

Molly's Motel on East Main Street was situated in the heart of Los Gatos, the "beauty spot of California" where visitors could enjoy a delightful year-round climate. Modern amenities in the 1950s included a television lobby and a heated swimming pool.

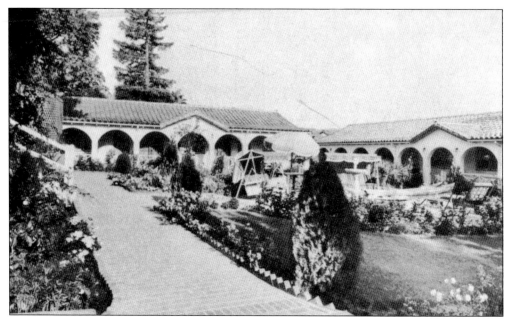

Molly's Motel was a complex of 12 apartments "of Spanish atmosphere" in the heart of Los Gatos. Each apartment had a living room, bedroom, bath, and kitchenette. Marilyn Monroe and Joe DiMaggio reportedly spent a honeymoon night at the motel.

In 1876, the governor of California had his hunting lodge on the site of the La Hacienda Inn. A century ago, the site was a stage stop on the overland route from the Midwest to Monterey. In the early 1900s, trolleys carrying San Francisco's elite would bring guests to what was then known as Nippon Mura.

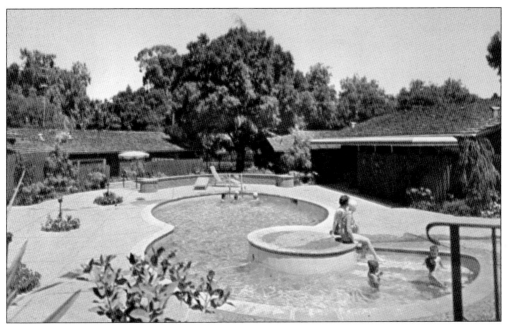

La Hacienda is located on property once part of the Rinconada land grant. In the early 20th century, it was known as Nippon Mura (Japanese Village) where the 30-acre tea garden resort was surrounded by koi ponds, Japanese arches, and wisteria vines.

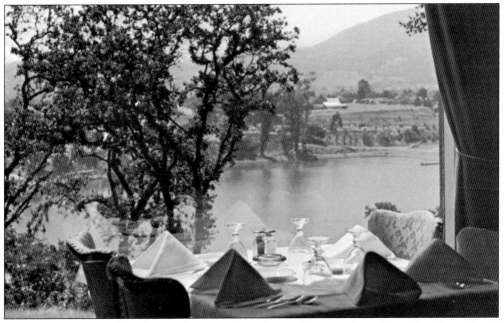

For over 40 years, Villa Felice Lodge was situated on what was Santa Clara–Los Gatos Road, later known as Winchester Boulevard. It was built amid huge oaks, pines, and redwoods with a view of Lake Vasona and the Santa Cruz Mountains. Legions of visitors enjoyed the quiet restful atmosphere, but in 1998, it was closed and the land sold for residential development.

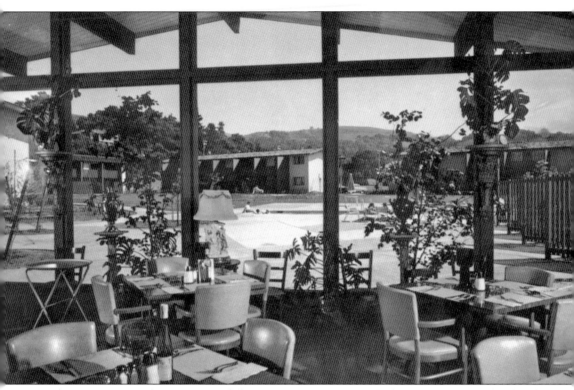

The Los Gatos Lodge was masterfully conceived in 1958 with the gracious warmth of early California hospitality in mind. The resort was situated on seven landscaped acres in the foothills and close to the charming shops of Los Gatos.

Nine

THE VIEWS

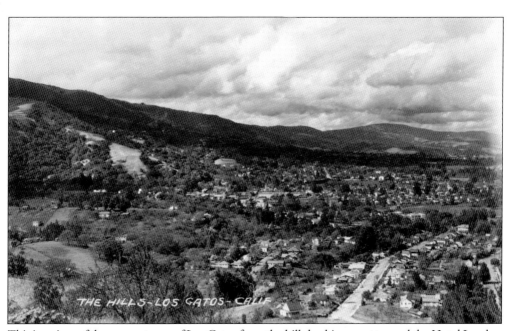

This is a view of the young town of Los Gatos from the hills looking west toward the Hotel Lyndon and the train depot. The spires of the Christian church and First Presbyterian Church are visible as are the roads that would have led to San Jose, Saratoga, and up into the hills toward the Novitiate.

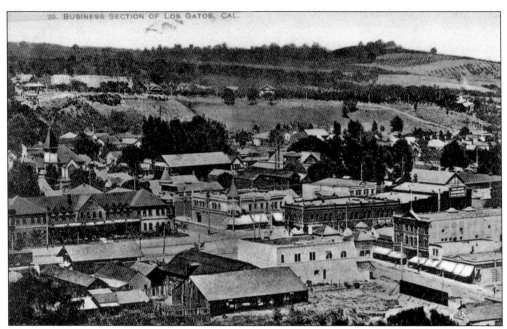

This 1800s scene is described as "Business Section of Los Gatos, Cal." The Hotel Lyndon, the Hofstra Block, and the train depot are seen on the left. The steeple of the First Baptist Church on Lyndon and Main Streets is visible behind them, and an orchard can be seen on the top left.

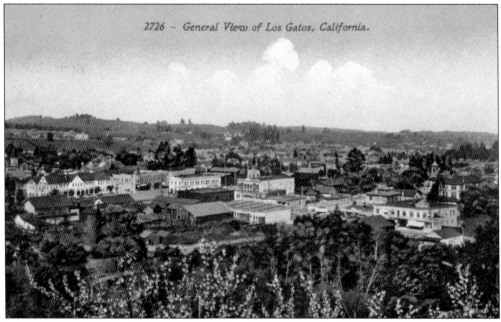

2726 – General View of Los Gatos, California.

This view is to the north and west. The large white building on the left is the Hotel Lyndon. Immediately to the right of the hotel across West Main Street is the Hofstra Block, now called La Canada Building. The white building across from the Hofstra is the Therese Block, named by John Lyndon for his first wife. Also noteworthy are the Los Gatos Central School and the Carnegie Library, both on University Avenue.

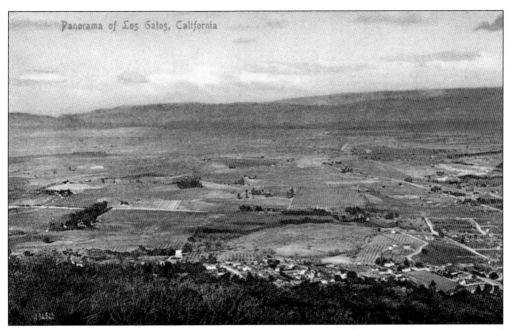

This panoramic view is of the town of Los Gatos, situated in the lower right-hand corner, and the valley beyond would be looking in a northeasterly direction. The electric light poles along the railroad tracks are just visible, and the proliferation of orchards extends as far as the eye can see.

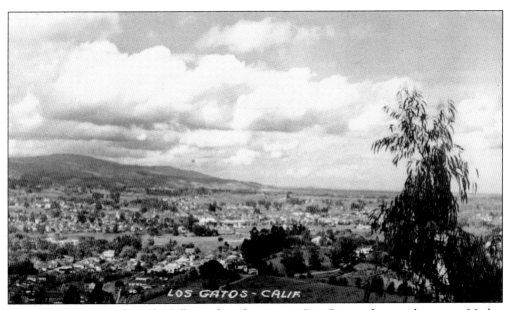

In this scene looking from the hills north and west over Los Gatos, what was known as Market Street and now as Loma Alta, is in the lower left leading to what was San Jose Road, now Los Gatos Boulevard. The tree in the foreground could be a eucalyptus, many of which populate the area.

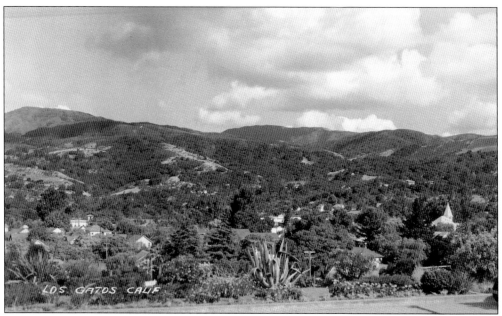

This view was most likely taken from the Glen Ridge area situated northeast of Santa Cruz Avenue. The spire of the First Baptist Church, built in 1889 and purchased by the Christian church in 1917, can be seen on the far right. The bell tower of the grammar school building on University Avenue is visible on the left.

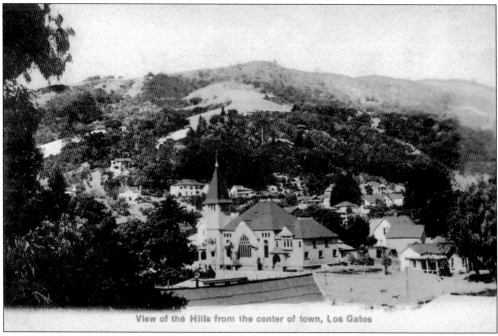

View of the Hills from the center of town, Los Gatos

This is an excellent photograph of the First Baptist Church, built in 1889 and purchased by the Christian church in 1917, on Lyndon and West Main Streets. A Blymer bell weighing 1,100 pounds was placed in the belfry and could be heard from 8 miles away. Due to a defect, it developed a deep crack and had to be replaced in 1895.

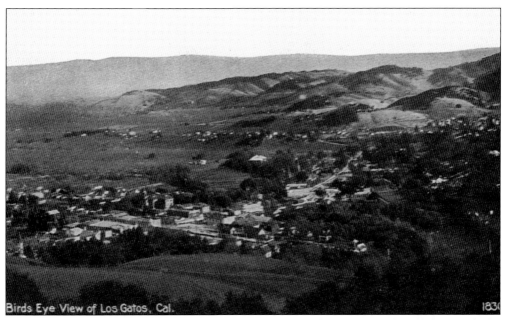

This bird's-eye view is to the northeast. The distinctive spire of Lyndon Heights, the home of John Lyndon, can be discerned on the far left of the photograph. The Hotel Lyndon is hidden behind the trees, but the train depot, University School tower, and Carnegie Library are easy to spot

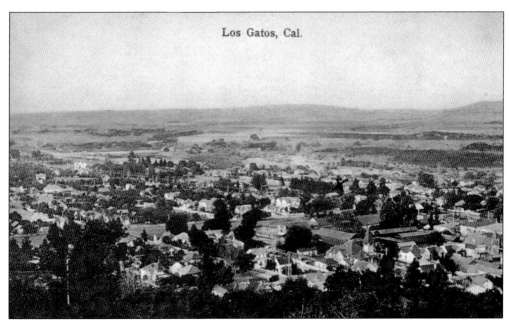

A closer view from the previous northeast vantage point shows the Los Gatos Cannery situated in the center of the photograph. The fire bell tower is to the right of the cannery, and the wide dirt road running left to right is the road leading west to Saratoga, now Highway 9.

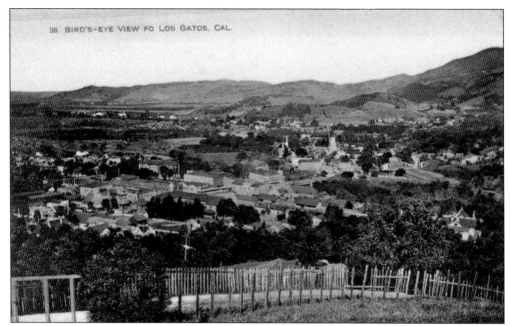

Another bird's-eye view is shown here looking over the town, with all the early landmarks clearly visible: the Lyndon Heights cupola to the right, the train depot to the left, and the corner of Santa Cruz Avenue and Main Street with the Hofstra Block on one side and the Bank of Los Gatos on the other. The grammar school, Methodist church, and Main Street, meandering east, are at center right.

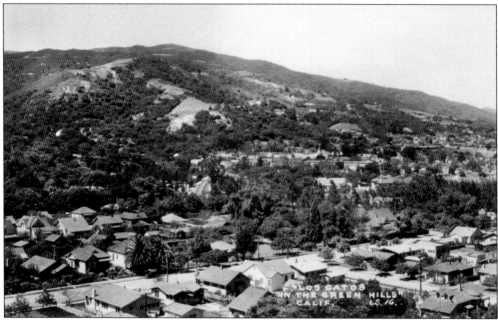

This 1920s scene at the crossroads of Loma Alta and Main Street clearly shows an increasing number of houses and decreasing number of orchards. The bridge and Forbes Mill are hidden beneath the trees, but the mission revival–style high school can be seen in the midst of the new additions that surrounded and eventually replaced it.

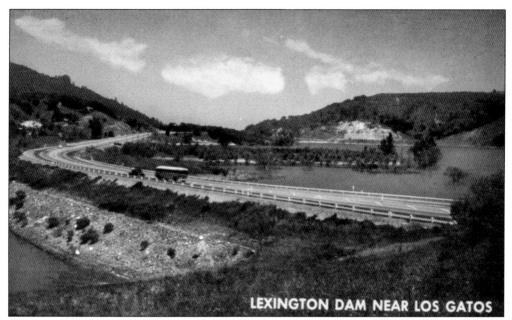

LEXINGTON DAM NEAR LOS GATOS

Construction of Lexington Dam and Reservoir was completed in the fall of 1952. The dam was originally referred to as "Windy Point Dam." In 1947, the directors of the water district decided to name it for the community of Lexington that was sacrificed when the reservoir was built. In 1966, the dam was renamed for James J. Lenihan, a long-serving director of the Santa Clara Valley Water District.

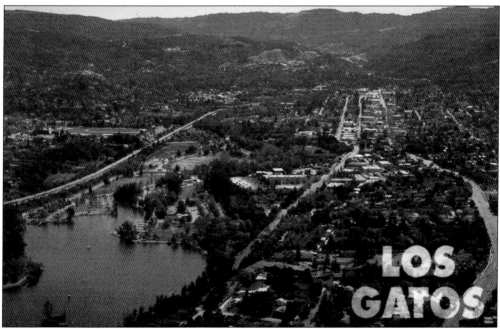

LOS GATOS

Vasona Lake Country Park was a welcome addition to the geography of Los Gatos. The 151-acre park surrounds a 57-acre lake created in the 1950s by damming Los Gatos Creek. It is a wildlife refuge with walking trails, a playground, and numerous picnic areas. It is adjacent to Oak Meadow Park, where the Billy Jones Wildcat Railroad is a popular attraction.

BIBLIOGRAPHY

Bruntz, George G. *The History of Los Gatos.* Santa Cruz, CA: Western Tanager Press, 1983.
Conaway, Peggy. *Los Gatos.* San Francisco, CA: Arcadia Publishing, 2004.
———. *Los Gatos Generations.* San Francisco, CA: Arcadia Publishing, 2007.
Dallas, Alistair. *Los Gatos Observed.* Los Gatos, CA: Infospect Press, 1999.
Jensen, Billie J. and Reece C. *A Trip Through Time and The Santa Cruz Mountains.* Gardnerville,
 NV: Ghastly Gallimaufrey, 1994 and 1998.
Kelley, Edward with Peggy Conaway. *Railroads of Los Gatos.* San Francisco, CA: Arcadia
 Publishing, 2006.

ABOUT THE ORGANIZATION

Early in 2003, Los Gatos Public Library began a local history project in response to a community that loves its cultural heritage. Staff set about organizing and cataloging existing library materials of a historic nature, some dating to the 19th century. Many of the items are fragile and needed to be stored in appropriate acid-free containers. A small Local History Room was established at the library in order to provide work space for staff and volunteers and to increase security for the many valuable and irreplaceable materials in our archives. The library was soon joined in its preservation efforts by the Museums of Los Gatos. Both the public library and the history museum wish to preserve and make accessible those materials, which can help residents know and better understand the community's heritage. Both organizations have limited staff and funding, but both also have valuable, important, and often complementary collections relating to our history. The idea of a partnership, formed especially in an effort to digitize our historic images, seemed like a natural thing to do. The two institutions had existed "side-by-side" for many years and in fact are located across the street from each other, but they had not worked together in a significant way in the past. Approximately 75 individuals and 25 companies, organizations, clubs, and associations have contributed money, equipment, or time to "Hooked on Los Gatos: The Library and Museum History Project." About 35 family collections will be represented in our cooperative database. To date, nearly 3,000 historic photographs, maps, death records, and other materials have been scanned, and many will become available on this site as the project progresses. The *Los Gatos Weekly Times* has generously allowed scanning of their archives. Students, researchers, genealogists, and people who love history will appreciate the wealth of information available about Los Gatos as the project develops. For more information, visit our Web site: historylosgatos.org/index.php.

ACROSS AMERICA, PEOPLE ARE DISCOVERING SOMETHING WONDERFUL. *THEIR HERITAGE.*

Arcadia Publishing is the leading local history publisher in the United States. With more than 4,000 titles in print and hundreds of new titles released every year, Arcadia has extensive specialized experience chronicling the history of communities and celebrating America's hidden stories, bringing to life the people, places, and events from the past. To discover the history of other communities across the nation, please visit:

www.arcadiapublishing.com

Customized search tools allow you to find regional history books about the town where you grew up, the cities where your friends and family live, the town where your parents met, or even that retirement spot you've been dreaming about.